CUT & SEA

揭 視 點

Tobias Klein

[*Opening...*]

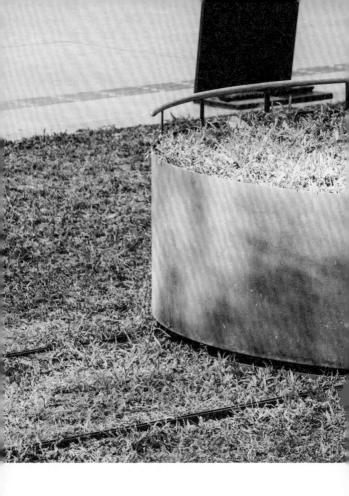

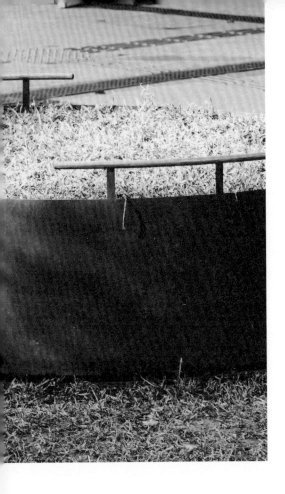

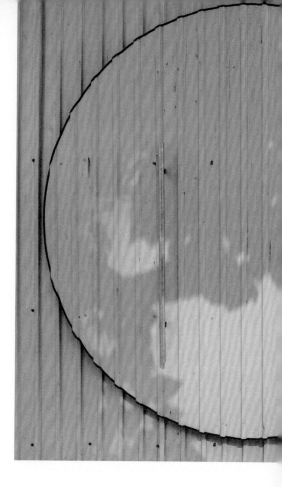

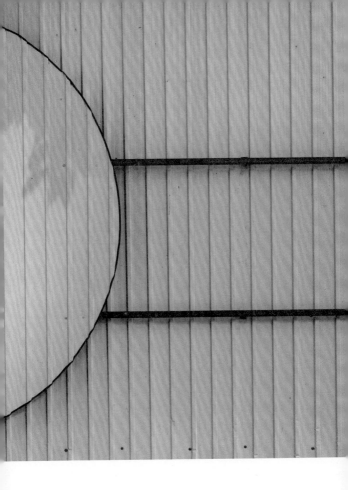

Content

Prologue

Florian Knothe

The visual concept of Tobias Klein's most recent installation, *CUT & SEA*, is remarkable, and his overall outlook, interpretive skills and consequent artmaking form a process well worth studying. Trained as an architect, Klein constructs in two and three dimensions. His artworks generally present a sequence of layers carefully composed and assembled into a complex structure—either flat or with volume—that can elude the builder's scientific rational.

Klein positions his artworks within an environment and considers the pre-existing aesthetics as he embellishes with layers of his own. Whether interior or exterior spaces, the placement of his 'mind-piece'—the masterpiece made and selected for a particular site—immediately connects with and reacts to its locale, transforming and cleverly incorporating both previous and new work into a complete form, a 'Gesamtkunstwerk'.

Klein's disposition as a master of digital craftsmanship is paired with an impeccable sense of form and colour. His polychrome works are pure art and his monochrome sculptures built monuments that connect both time and space. Reminiscent of art forms rooted in European Renaissance and Baroque culture, Klein's 3D-printed objects bridge past and present, as well as tradition and innovation. The master's art is—and this is what sets the constructions apart from other contemporary works—a clever mediator of space, time, culture and scientific development.

序 言

羅諾德

Tobias Klein 最新的藝術裝置《揭視點》的視覺概念令人驚歎不已。他整體的視野、詮釋技巧及隨之而塑造的藝術創作，構成一個值得深入研究的過程。作為一位建築師，Klein 以二維與三維角度進行建構。其藝術作品普遍呈現出一層一層經精心組合與裝配而成、足以難倒修建者的科學理性的，或平面或立體的複雜結構。

Klein 將其藝術品置於一個環境之中，為了能以自己多重的美學概念為先前既有的美學錦上添花，他亦會究察過往的美學。不論是室內或戶外空間，Klein 的「心思作品」——為特定地方製作和選取的大師級作品的放置——都能立即與現場連結並作出回應，變換及巧妙地將昔日和嶄新的作品組成一個完整的形式，一種「整體藝術」。

Klein 矢志成為一位數碼工藝大師的意向，並他對結構和顏色無懈可擊的觸覺相輔相成。他的彩色作品屬於純粹的藝術品，單色雕塑則建造出各個連結時間與空間的不朽佳作。Klein 的三維打印作品架連過去與現在、傳統與創新，令人聯想起紮根於歐洲文藝復興與巴洛克文化的藝術形式。這位大師的藝術是一個空間、時間、文化與科學發展之間靈巧的中介者，亦正是這個特點使它於眾多當代藝術中別樹一幟。

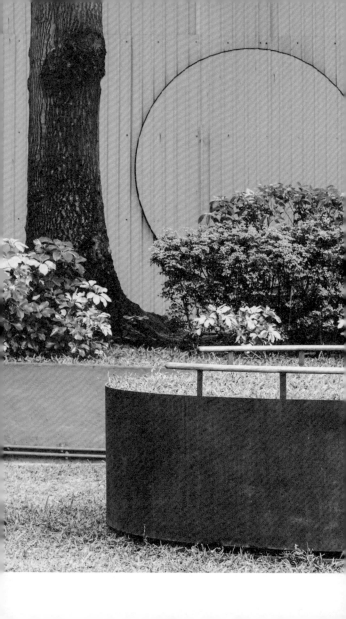

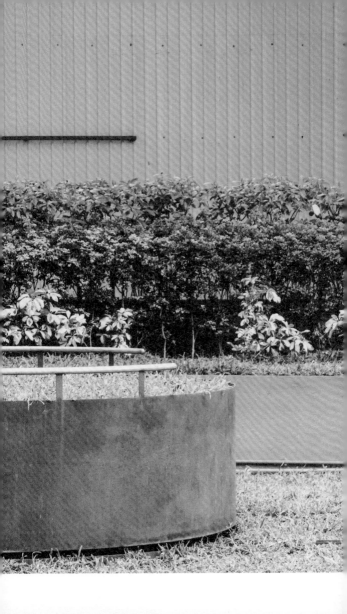

Back to the Basics

Ivy Lin

Oi! strives to explore the interrelationship between art and the nature of its existence in ordinary life.

Oi! (Oil Street Art Space) stood on the waterfront, but time never stops, and as the months and years passed, the shoreline gradually moved north. High-rise buildings erected on the reclaimed land block the seascape, while also disconnecting people from strong neighbourhood networks and nature. The relationship between Oi! and the ocean is now so near and yet so far away. Gradually, we got used to it, but we believe art connects these relationships.

Tobias Klein created *CUT & SEA* to offer new insights into the urban landscape. CUT refers to two 2.5-m circular cutouts that the artist has made in the lawn and fence of Oi!, revealing the stripped truth of the landscape underneath and behind the discs that cover them. Visitors are invited to move the two discs so that they are either open or closed. The cutouts are intended to trigger our memories and imagination of the sea that used to be here, but that is no longer close by. Looking through the open cutouts, visitors can discover the makings of the city and see from a distance the sky and sea, which have gradually moved away from us. Interaction with the installation connects humans, earth, heaven, the ocean and nature and reveals their interrelationship, as communication in society is encouraged.

The 'tourist gaze' suggests that the experience of the tourist involves a particular way of seeing; what tourists see tends to be distinctive and extraordinary. The architecture and works of art on display at Oi!,

還原 基本

連美嬌

油街實現不斷嘗試發掘藝術在尋常生活中的形相及力量。

油街實現原位處海濱，但桑海蒼田，海岸線不斷北移。城市填海造地建出高樓大廈，遮擋人們的視野，阻隔了人與人、人與海之間的連繫。油街實現與海的關係既遠且近，我們已習慣了這個隔膜。希望透過藝術的手法把多重的屏障打開。

Tobias Klein 創作《揭視點》，為城市景觀帶來新視點。《揭視點》的標題 CUT & SEA，CUT 是切割，藝術家把油街實現的草坪和圍欄打開了一個直徑 2.5 米的圓形割口，讓背後的景觀真實及赤裸地呈現。觀眾可自由移動圓蓋，把切口打開或閉上。這個切口喚醒觀眾對那近在咫尺、曾經接壤的海洋 (SEA) 的回憶與想像；觀眾打開圍板的切口，可以窺看到城市的建造過程，遙望那漸漸遠去的天空和大海；透過與裝置互動，人與大地、天空、海洋、大自然產生連繫；更進一步與我們的毗鄰作互動溝通，建立連結。

觀眾在參觀的過程中會「凝視」遇見的事物，一切因此而變得不平凡。油街實現作為二級歷史建築和藝術空間，建築本身與其內在的藝術品也成為「凝視」的對象。觀眾窺探作品圓板下的秘密。驚訝圓板背後只有泥土和建築工地，是赤裸裸的真實，沒有矯飾。作品的切

as a Grade II historic building and an art space, fit these criteria perfectly. Intrigued, visitors will look at what is hidden behind the discs. To their surprise, there is nothing but the reality of earth and buildings, without artifice. The cutouts act like magnifying glasses, allowing us to focus on different parts of the surrounding buildings and natural environment. *CUT & SEA* turns them into the objects of our 'gaze', transforming our daily existence and inspiring audiences to think again about our history and our life.

The participation and interaction of visitors are essential to the completeness of *CUT & SEA*. The work will tell you the story of the district and reveal the design and nature of our constructed city, as well as establish the relationship between people and the city.

口仿如放大鏡般，呈現城市的各樣細節。《揭視點》將自然和建築轉化為「凝視」的對象，轉化日常，啟發觀眾思考生活，反思歷史。

觀眾的參與和互動令《揭視點》變得完善，讓作品訴說地區的故事，揭開城市建造的結構，與人及城市建立連繫。

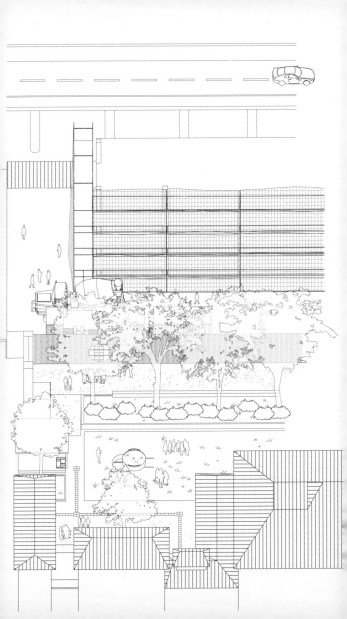

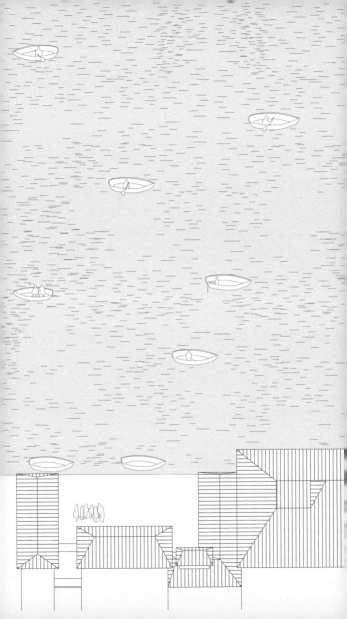

CUT & SEA 揭視點

Oi! 油街實現
16.12.2017 – 22.4.2018

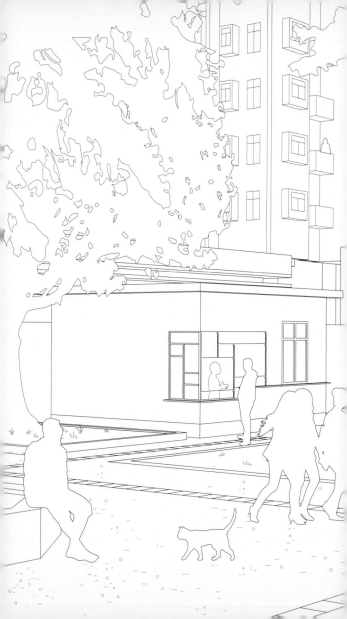

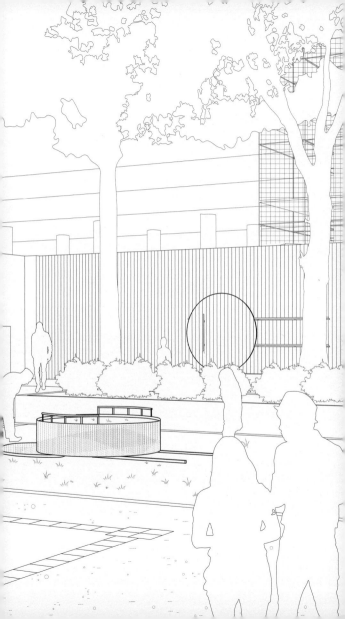

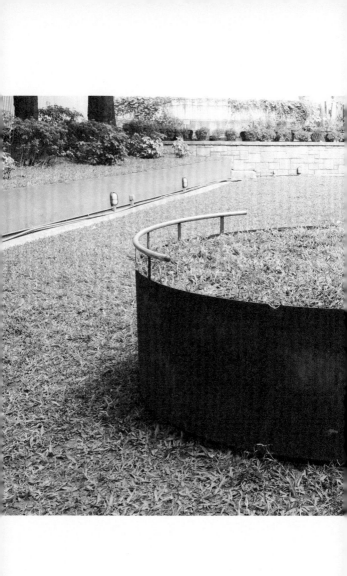

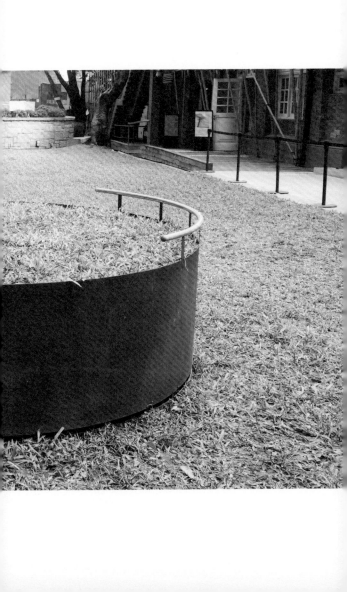

Reflections

Tobias Klein

CONVERSATIONS

The project *CUT & SEA* began with an invitation
to meet at Oi! (Oil Street Art Space) with Ivy Lin,
Curator of the Art Promotion Office for Hong Kong's
Leisure and Cultural Services Department. At the
time, I assumed that we would discuss my recent
installation *Simulacra Naturans*, which was being
exhibited at Hong Kong Park, as both the Oil Street
Art Space and Hong Kong Visual Arts Centre are
managed by the Art Promotion Office. I was greeted
by Ivy and her colleagues Carol Chung and Vicky Ho.
We met on the first floor of the main building of the
Art Space. It was a warm October afternoon and we
drank tea. The noise from two adjacent construction
sites was at first a nuisance, but soon became part
and essence of the ambient character, and to a
certain degree, the subject of our conversation.

> *Located in the frenetic neighbourhood of
> Fortress Hill, Oil Street Art Space comprises
> a courtyard framed by the former yacht
> clubhouse, listed as a Grade II historic building
> since 1995, and a series of annex buildings to
> the south that house the administration of APO
> as well as several exhibition spaces on the
> ground level. The grass courtyard and gallery
> spaces enclose the visitor within an amalgam
> of historical and contemporary structures. The
> entrance from Electric Road on the southern
> side is sandwiched between these historic*

反 思

Tobias Klein

對　話

《揭視點》的緣起，來自於藝術推廣辦事處的館長連美嬌的邀約，邀請我到油街實現會面。當時我猜想會面的目的，是討論我近期在香港公園展出的裝置《自然不自然》，因為油街實現和香港視覺藝術中心都是藝術推廣辦事處轄下的藝術空間。會面當天，在場除了有連女士外，還有她的同事鍾詠琪女士和何艷婷女士。當天是十月份一個和暖的下午，我們坐在油街實現辦事處的一樓喝茶。來自隔鄰兩個建築工地的噪音起初有點滋擾，但很快便變成整個環境的一部份，某程度上，噪音還成為我們談話的主題。

油街實現位於煩囂的炮台山，中間的庭院被自1995年起列為二級歷史建築物的前遊艇會會所及南端的一系列附屬建築圍繞，後者現為藝術推廣辦事處辦公室，地下則設置展覽廳。遊人來到種滿青草的庭院，四周被歷史與現代建築包圍。電氣道的南端入口兩旁，分別有歷史建築及附屬樓，設有社區廚房。在西端，油街被社區廚房和小更亭遮擋，而西北角有一條小車路。庭院的北面有一道灰色金屬牆和一列大樹劃分邊界，樹和臨時性的牆分隔了旁邊的大

buildings and the annex, which houses the social kitchen. On the western side, Oil Street Art Space is hidden by the kitchen and a small guardhouse. In the northwestern corner is a smaller car access road. The northern side of the courtyard is fenced off by a natural palisade of large trees and a grey sheet metal wall. Both the trees and the temporary wall mask the large construction site next door. Before this construction yard emerged out of the reclaimed land, the neighboring plots were only separated by a small 1.7-m tall metal mesh fence—airy and permeable. Now the metal wall only partially hides the emerging skyscrapers, cladded in light green construction fabric. Outside the gate to the car access road, the construction workers are on their cigarette breaks—separated from the courtyard—as smoking is not allowed on the grounds. To the east lies uncertainty, marked by the groundskeeper's shed and a haphazard strip of bushes that await the extension of Oil Street Art Space in 2019.

This setting creates an inward-looking courtyard and is reminiscent of a cloister construct, or a secret garden. Time stands still in this space. The context of the neighborhood is muted by its walls, or perhaps, strangely, by the forest of skyscrapers. Naturally, the view turns towards the empty lawn in the centre, inviting contemplation. Oil Street Art Space's buildings are historically displaced in a city that rebuilds before it preserves. However, this conservation is not to be mistaken for living in the past. The exhibitions housed at Oil Street Art Space, its concept of a social kitchen, with collected and recycled food, its washbasins outside the toilet, the octagonal bench surrounding the southern tree, all create a sort of eternal present—a bubble in space and time where one can stop and reflect.

型建築工地。在填海工程把隔壁變成一大片工地之前，只有一道 1.7 米高、通風又透氣的小鐵絲網隔兩個地區。現在，金屬牆只能遮擋逐漸成型、被淺綠色建築布包圍的高樓的一小部分。在車路入口的大門外，建築工人正在吸煙，但與庭院保持距離，因為油街實現區域之內不允許吸煙。東面有一種不確定性，管理員的更亭與一排雜亂的灌木叢，正靜待 2019 年油街實現的擴建。

這環境營造出一個內向的庭院，讓人想起修道院建築或秘密花園。時間在這空間內停留。毗鄰的環境被牆壁以及（吊詭地）由高樓大廈形成的混凝土森林所掩蓋。自然地，人的視點轉向庭院中心的草坪，鼓勵人們沉思。油街實現的建築在這個擅於重建而非保留的城市中顯得錯置，但這建築物的保留不應被視作活在過去。在油街實現舉辦的藝術展覽、回收及循環再用食品為概念的社區廚房、廁所外的洗手盆，以及南端圍繞大樹的八角形長凳，營造出一種永恆的現在——是一個在時空之內可讓人停下來反思的泡泡。

回到我與連女士和她同事的對話——我向她們簡介了我的作品《自然不自然》。這個由香港視覺藝術中心委約的作品，質疑我們對荒野和自然的觀念及製造與超真實的關係，通過對比公園與再現被打斷的「野外」，放大了公園的人工性。我創造了三個時刻，讓公園的真實性被自己的反射影像所打斷。在公園中央的湖邊，放置了三個燈箱，每一個都分別展示了該處的三維素描

Returning to the conversation with Ivy and her colleagues—I introduced the work *Simulacra Naturans*. Commissioned by the Hong Kong Visual Arts Centre, it questions our perception of wilderness and nature and the relationship between the constructed and the hyper-real. The work amplifies the artificiality of the park by contrasting it with a disrupted 'wilderness' of its own representation. I created three moments in which the reality of the park is disrupted by its own reflected image. Three light boxes were placed around the park's central pond, each containing a print displaying a 3D scan of the location in which it was placed. The prints were made using viewpoint-dependent lenticular printing technologies. This allowed me to create an auto-stereoscopic 3D type of vision, creating an immersive alternate reality of the park in which the scans were installed. The result was a recreated, 3D scanned park, reconstituted as a copy of itself projected onto a second alternate reality. It was up to the visitor to look at these works from different angles in order to discover the depth of the re-creation. By presenting a copied and 'prettified' version of nature, the work argues for Hong Kongers to take a critical stance on the artificial nature of the park and, by extension, the nature of city life—tamed and declawed. By showing the visitor an alternative, unstable, natural world—*Simulacra Naturans* emphasises the artificial nature of the park and encourages speculation on its extent to the city, and to the entire island.

Hong Kong appears to us as a green island. The city exists as a niche between the evergreen of the hills and the water's ever-grey. We look out into the green around us: is this real wilderness or just wallpaper decorating the countless architectural sins of this city?

The idea of wilderness is exciting to us. But there is no space for wilderness in our highly stylised and controlled lives. The ground we walk on is

reclaimed from the sea. The mountain slopes are cast in concrete. The hiking trails are secured and well maintained. The playgrounds use green rubber flooring as a substitute for grass. What is natural in this nature? Indeed, where is nature?

We find nature in Hong Kong Park. A park is nature perfected. But the nature in the park is a construct. Everything—from the trees, shrubbery, flowers and turtles—is placed carefully to create a surrogate of a more natural form of nature. This park has been created to offer us a space of preserved wilderness.

Within the designed and inherently unnatural world of the park, my works of art are foreign bodies. They offer moments of disorder. They represent wilderness. They call on the viewer to visualise how the boundaries between wilderness and park, between reality and illusion, are not heavy like a turtle, but light as a butterfly. As Hong Kongers, we should not forget this.

Speaking with Ivy and her team, I suggested we continue and extend this project onto the grounds of Oil Street Art Space.

> *The sound of the two construction yards intensified as the afternoon progressed. The site at the back of the Oil Street Art Space was in its initial phase and a battering ram was driving retaining walls into the ground. The monotonous thud of steel on steel was calming, each thud was predictable. This ground was once the shoreline. The land was reclaimed from the sea. This land, like the surrounding buildings, and like Hong Kong Park, is an artificial construct. It contains a calculated and engineered amount of sand and stones, layered at a particular depth. Wilderness, even at ground level, was long gone. Instead, the earth was replicated and engineered.*

照片，這些照片使用依賴視點的透鏡印刷技術製作，創造出類似自動立體視覺效果，建立一個讓人置身其中、描繪裝置所處之公園角落的虛擬現實。結果一個重塑的真實三維素描的公園，化成自己的複製本，再被重新投影成為第二個虛擬現實。觀眾可從不同角度觀看這些作品，從中發現我提供的重塑現實的深度。通過展現一個複製和美化的大自然景象，這作品讓香港人以批判的角度審視公園的人工性，同樣也可伸延至整個城市的特性──被馴化和卸甲。《自然不自然》通過向觀眾展示另類和非固定的大自然，除了強調公園的人工性外，也鼓勵思考這城市以至整個香港島的人工性。與連女士和她的團隊的對話中，我建議把這作品伸延到油街實現。

午後，來自兩個工地的噪音越來越大。位於油街實現後方的工地正處於初期施工階段，打樁機正把護土牆打進地下。鋼鐵與鋼鐵的碰撞聲節奏有序，讓人感覺平靜。這泥土屬於原來的海岸線，這片土地是填海得來。土地與周圍的建築物，就如香港公園一樣，都是人工製造。這塊地含有經計算和經營的份量的沙和石，鋪陳至一定的深度。即使在土地的層面，荒野早已消失。相反，土地是被複製和設計。

若我們坐在1908年建成的皇家香港遊艇會會所大樓上層，眼前出現的會是停泊在前面的船隻，耳邊聽到的是海浪輕輕拍打碼頭的聲音，觀看靠岸遊艇的帆柱輕輕地來回搖擺──這節奏可能與現時打樁機的撞擊聲相似。現實中的油街實現前面沒有帆、帆柱或藍色的波浪，我

Sitting on the upper floor of the 1908 clubhouse of the Royal Hong Kong Yacht Club, we would have overlooked boats moored in front. We would have listened to the waves gently caressing the pier and watched the masts of the mooring yachts rocking gently back and forth—in a rhythm perhaps similar to the hammering of the construction behind us. Instead of the sails, masts or waves of the blue sea, we gazed at the wavering green nets covering the unfinished skyscraper in front of Oil Street Art Space. The sea was far away. This was not a yacht club anymore.

The topic of our conversation shifted. Instead of replicating and extending the notion of an artificial form of nature, Ivy proposed an art intervention that would address the history and current conditions of the art space. She asked if I could propose a small work to coincide with the Hong Kong Biennale in Architecture? I could look at both the history of Oil Street Art Space and its urban surroundings as a contribution to the architectural festivities. The afternoon waned and one shift of workers started to leave the construction yard in front, while the next shift prepared to take over the hammering. Sitting on the first floor, I looked down upon the lawn. Staring at a green lawn framed by a grey wall from the first floor of what was once a yacht club, built on reclaimed land, seemed to be a good starting point to think about the history and future of this neighborhood, and by extension, the history and future of Hong Kong, and our role within it.

們看着蓋在未完成的高樓大廈之上的綠色網布停止晃動。海已離我們很遠，油街實現也不再是遊艇俱樂部。

我們的話題一轉，連女士建議我們不重複和延伸《自然不自然》所表達的人工自然，反而創作一個對應我們身處的藝術空間有關歷史與現況的作品。她問我可否配合香港建築雙年展製作一件小型作品。我可以把油街與及周遭環境的歷史融入作品之中，作為慶祝建築雙年展的一個部份。那天隨着下午過去，日班的建築工人開始離去，夜班的工人準備繼續打樁工程。我由從前是遊艇會會所的一樓往下望，看着這一片從填海地建成的大樓以及被灰色的牆包圍的草坪，想到這是反思這社區以至整個香港的歷史與未來，以至我們身處其中的角色的極佳起點。

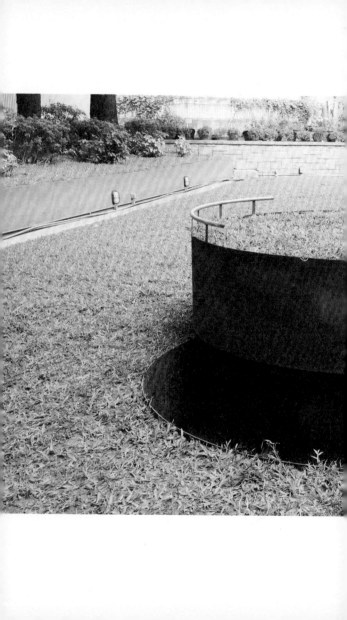

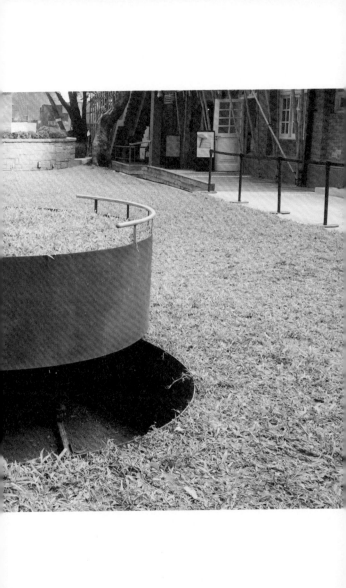

DIRECTIONS

The dominant direction of Oil Street Art Space is inward. All energies are centred and articulate this inward-looking continuum. This could be stated for Hong Kong Park as well and, by extension, for the island of Hong Kong. An alternative to the centric motion of a system is to view the system from the outside, reversing its directionality. In physics, this would be the difference between centrifugal and centripetal. In Oil Street Art Space this would mean to reverse the linear directions in order to break the self-reflected contemplation without destroying its calming qualities. This new directionality requires a centre point from which to look forward and backward in time. Like a set of scales, a visitor would need to be able to push weights along a measuring line to reach equilibrium, or to distort it. Like a corridor or sliding door, the work would need to create ways in and out and to generate a porosity that would allow a repositioning of anyone walking along this time-continuum. I thus devised the first axis through the space. Given the nature of Oil Street Art Space and its introverted courtyard, this could not be an ordinary line connecting two points as in a Cartesian system. Instead, I sought out a relationship between simultaneous narratives, one vertical, looking up to the sky and down to the ground, the other horizontal, cutting across time and a layered history. Both are places to inhabit and directions on which to reflect.

The first direction is vertical. We face the sky as a projection ground, where clouds are continually redefining a picture not painted by us.

方　向

油街實現的主要方向是內向的，所有能量都集中表達這內向的連續性。同樣香港公園也可被視為香港島的延伸。一個中心運轉的系統可從外邊看，改變其軌跡，就正如在物理學中有離心或向心之分。在油街實現中，意味着扭轉線性方向以打破自省的沉思，同時不會破壞其平靜。這個新方向，需要一個能夠同時瞻前和顧後的中心點。就像一個秤一樣，訪客需要能夠沿着測量線推動秤砣以達至平衡點，或者扭曲它。像走廊或拉門一樣，這作品需要創造入口和出口，並產生孔隙度，為任何沿着這個時間軸行走的人重新定位。因此我定下了第一條穿越空間的軸。考慮到油街實現的內向式庭院，這條軸不可能是依照笛卡爾系統、連接兩點的普通路線。我反其道而行，找到了同時發生敘述之間的關係，一個垂直的，仰望天空直到地面，另一條則是水平的，跨越時間與不同的歷史層。兩者都是可駐足和反思的據點。

第一個方向是垂直的。我們從地下面向天空，雲層不斷重新繪畫一幅不是由我們創作的圖畫。從另一面看，我們站在歷史的土地上。屬於現在的沉積物全部都將成為被稱作的地面層，含有恐龍化石和曾經漫遊在地面的生物。地面由土壤、泥土和岩石組成，在此之下是地球的溶火之心。地面是兩個未知體積之間的一道薄薄表層，分別是沉重的和黑暗的地球與及無重量又宏大

In the other direction, we stand upon the ground as history. Sediments of the present become layers of the construct called ground, containing dinosaur fossils and the biological matter that once roamed the surface of the present day. Ground is made of earth, mud and rock, beneath which lies the molten core of the planet. The ground is a thin surface between two unknown volumes—the earth, heavy and dark—and the sky, weightless yet immense. Returning to Hong Kong and to the battering ram that resonates through the ground of Oil Street Art Space, we walk upon a stable equation. It is this new ground that we have made, reclaimed, or stolen from the sea. We have created our own ground and collapsed a mystery.

The second direction is horizontal. We traverse the ground, looking and moving, forward and backward. On the surface of the earth, we are able to perceive a constructed space determined by the curvature of the planet. If our planet was only water, we would be able to see 8 km around us from a standing height of 175 cm. We would be surrounded by an infinitely thin line—the horizon. A step in any direction would allow us to see more in one direction and less in another—diametrically opposed to our movement's direction. Within this system, our every movement would create and destroy space. If we left this system in a spaceship, the constructed space would collapse—just like the physics of centrifugal and centripetal forces, we would see that our system only exists on a self-referential sphere. The horizon, the thin line separating up from down, is only 8 km away, yet it appears to be an infinite construction. It is both a manmade and natural phenomenon.

的天空。回到香港，隨着打樁機的聲音響遍整個油街實現，我們腳踏穩定的等式，即是我們製造的新陸地，是通過填海或從海竊取的土地。我們創造了自己的立足點，並瓦解了一個謎。

第二個方向是水平的。我們橫越地面，不斷觀察和移動、前進和後退。在地球表面上，我們能夠從地球曲率認知構造空間。若整個地球都是水，我們便可從175厘米的高度看到周圍8公里範圍。我們將被一條無限細長的線包圍——就是地平線。向任何一個方向移動，便可讓我們看到這方向的景物更多，而減少看到另一方向的景物，與我們移動的方向相反。在這個系統內，我們的每一個動作都會創造和摧毀空間。若我們坐太空船遠離這系統，這建造的空間就會崩潰——就像離心力和向心力的物理原則一樣，我們會明白我們的系統只存在於一個自我指涉的領域內。分隔上下的地平線離我們只有8公里，但卻看似無限，它既是人造又是自然的現象。

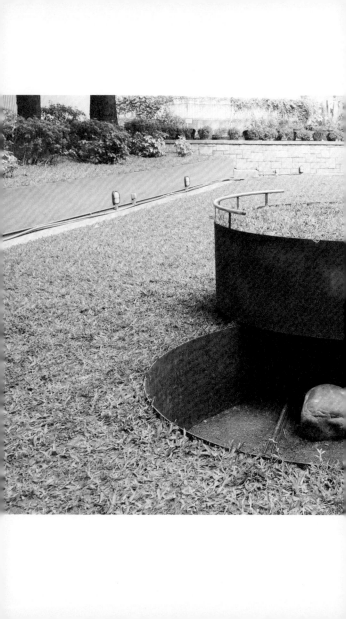

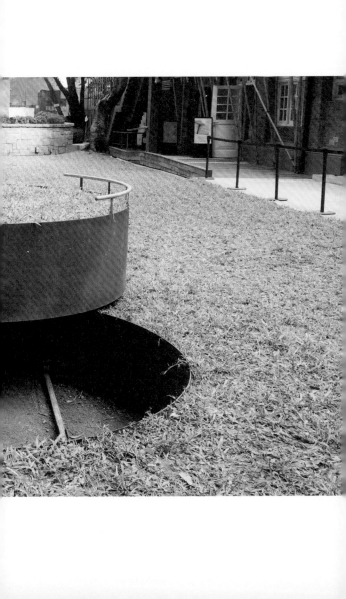

WE CUT WE ACT

Between the two directions—vertical and diagonal—lies an activating point where the two axes intersect—a point of origin, activation and observation. In the space of quantum physics, the point of observation collapses the uncertainty of a system—to observe is to intervene. In philosophical terms, the subjective observation of an event implies consciousness and awareness in the two different directions. Their intersection can be extended into the spiritual and metaphysical, where a system of duality—one positive and one negative—is negotiated and balanced by activation, usually by the human. We stand in the middle, at the intersection, at the position of observation and activation. We stand in the courtyard. We stand on the grass.

> *I think I left the conversation with a vague idea of how to respond to Ivy's idea of a historic relationship to this place. The work would need to be invasive, but not offer more than what was already there. To comment on the condition of the space, I would have to change the perception of it or to disturb its fundamental use. In order to change the perception of a space—a cultural entity or social ground—I decided that the anticipation and projection of oneself becomes the first priority. The expectations and projections we carry are our engines of perception and the tools with which we evaluate a situation.*

我們揭與動

在垂直和水平兩個方向，在中間垂直線和對角線之間有個激發點，兩個軸的相交點，是一個起點、激發和觀察點。在量子物理的空間中，觀察點破壞了系統的不確定性——觀察就是介入。在哲學層面，主觀觀察意味着意識和知覺兩個不同的方向。他們的交叉點可以延伸到精神和形而上學，當中涉及一個二元性系統——正面和負面通過激發實現協商和平衡——激發者通常是人類。我們站在中間，在十字路口，在觀察和激發的位置。我們站在庭院。我們站在草地上。

> 在那對次話後，我對如何回應連女士有關連繫這地方的歷史的建議有概括的想法。這作品必須具侵入性，但不能提供比現有更多的東西。要評論這空間的現狀，我必須改變對空間的認知，或從根本上打亂它的使用。為了改變對空間的認知——無論是作為文化實體或社會空間，我決定自我的期望和預測是優先的考慮因素。我們隨身攜帶的期望和預測，是我們感知的引擎，也是我們評估不同情況的工具。

在這場地上使用這兩個方向的概念，意味着我必須找到一個碰撞點，一個交匯或激發點。這兩條線需要打開和關閉、縮小和延伸、覆蓋和分離。時間和歷史背景的隱喻需以簡單的幾何形狀表達，以觸感的關係揭示嶄

To work with the notion of the two directions on this site meant that I needed to find a point of collision, a point of intersection, or a point of activation. These two lines would need to open and close, to shrink and extend, to cover and to separate. The metaphors of time and historical context would need to be readable as simple geometric shapes, tactile relationships that could reveal something new and unexpected, something that would allow the visitor to extend their own perception of the site along the vertical and diagonal lines of this intervention. This project does not change the site by adding to it, it simply reconfigures the energies of the site itself. Just as a window reveals what a wall occludes, my cuts into the site sought to reveal what lies beneath, or what is hidden behind. The surface of the site is pierced, excavated and cut. The openings of each line add tension to stabilise and destabilise the energy of the space.

> *I returned a week later to meet with Ivy and the team at Oil Street Art Space. We sat on the upper floor of the former yacht club. We drank tea. I presented a proposal for an artwork that—considering Ivy's brief of a small historical investigation into the space—seemed extreme. I presented a series of simple drawings that showed two large circles cut into the fabric of the Oil Street Art Space. The drawings showed the back wall being cut at the point of the security gate of the construction site. The second cut was located at the centre of the lawn in the courtyard. The drawings showed that both incisions would be 2.5 m in diameter and covered with the original surface material they were cut out from. In the case of the lawn, I proposed to excavate 60 cm of soil and have the earth framed by a steel cylinder that would move on rails. In the case of the wall separating Oil Street from the neighbouring construction site, I suggested we cut the wall and also*

新和意想不到的東西,讓觀眾沿着作品的垂直和對角線擴展自己對場地的認知。這作品不會通過添加某些元素來改變場地,而只是重新配置場地本身的能量。就像一扇窗戶透露一堵牆遮擋着的風景,我切入該場地的目的是試圖揭示隱藏在底下或背後的東西。場地的表面被刺破、挖掘和切割。每條線的開口都會增加張力,以穩定和干擾空間的能量。

一周後我回到油街實現再與連女士和她的團隊會面。我們坐在前遊艇會會所的上層喝茶。我提出了一件藝術品的建議,老實說,就着連女士要我作這場地的小型歷史探索的要求,現在的藍圖顯得頗極端。我讓她們看一系列簡單的繪圖,展示在油街實現切入兩個大圓圈。繪圖顯示在工地保安亭那面後牆切割第一個圓圈,第二個圓圈則在庭院的草坪中央。繪圖顯示兩個切口的直徑均為2.5米,並以原來的物料覆蓋。在草坪,我建議挖掘60厘米的泥土,利用可放在軌道上移動的鋼筒盛載。在分隔油街實現與相鄰建築工地的牆,我建議切割牆壁,並安裝在連接着牆上的軌道上。在提出這個有點極端的建議後,我預計會被拒絕。但相反,我們同意並進行計劃。

我們切割——我們行動。

*mount it on rails connected to the existing
wall structure. After proposing this somewhat
extreme intervention, I expected that it would
be rejected. Instead, we agreed and the
planning went ahead.*

We cut—we act.

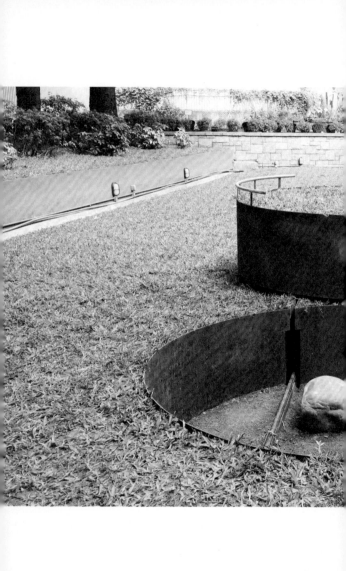

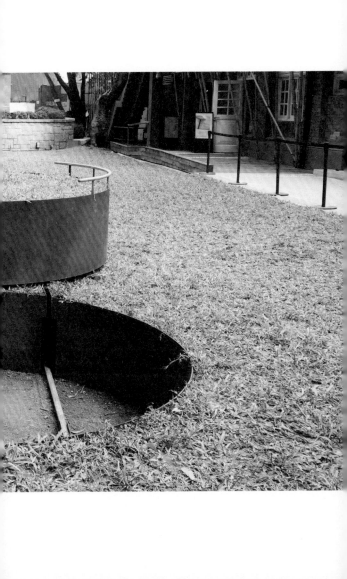

WE CUT AND SEA

On the 16th of December, the two incisions were opened to the public. The work was completed after less than six weeks of planning and construction. This was only possible due to the amazing collaboration with structural engineer Yasuhiro Kaneda and Mr Wong, an experienced metal contractor. During the four-month exhibition period, the wall transformed into a naturally animated painting— directing a performance between two unlikely neighbours, while articulating a relation of closed and open as a projection ground for the early sunrays of spring and the trees' shadows.

The soil was moved as the cylindrical excavation was opened and closed. Leaves filled the hole and occasionally the attentive staff cleaned them out. Everyday visitors came to open or close the metal lid to see what was contained inside the circular excavation. Some were disappointed and promptly closed it. Others stayed longer. During the exhibition period nobody tried to climb onto the grass lid of the excavation. Nobody tried to climb down the 600 mm. Wildflowers started to grow on the lid.

The two lines became activators of the Oil Street Art Space. They allowed reflection on the relationship of the space to its neighbours and the relationship between oneself and one's expectations of human relationships. *CUT & SEA* and *Simulacra Naturans* transformed the visitor into an actor, unlocking new optical, physical, socio-cultural and spatial relationships.

我們揭與視

12月16日，這兩個切口向公眾開放。作品從規劃到建造，整個過程不到六星期，全仰賴於結構工程師金田泰裕與及經驗豐富的金屬建造商黃先生的協作。在為期四個月的展覽期間，這面牆變成了自然的活動畫——在一對不尋常的鄰居之間作了一個表演，同時在早春的陽光及樹影之中，闡述了關閉和開放之間的關係。

圓柱形的洞能夠開和合，泥土隨之被移動。樹葉落在洞裏，偶爾油街實現細心的工作人員會清理落葉。每天訪客會來打開或關閉金屬蓋，看看在圓形洞內藏着甚麼。有些人失望地關上金屬蓋，其他人則駐足觀看。展覽期間，沒有人試圖爬上圓形的草蓋，也沒有人爬下那600毫米的洞。野花開始在蓋子上生長。

這兩條線成為油街藝術空間的催化劑，允許反思空間與鄰居之間的關係以及自我與人際關係的期望。《揭視點》和《自然不自然》將訪客轉化為演出者，釋放新的光學、物理、社會、文化和空間關係。

我們打開了地面。用鋼製成、裝滿土壤和蓋着草的圓柱很難移動，它是沉重的，需要體力來打開和關閉這個洞。很多人試圖猜測我們埋下甚麼在地底。畢竟，作為填海地，應不會有甚麼令人意外的東西。但由於油街實現具有豐富的歷史，可能會有許多驚喜等待挖掘。我們把

We opened the ground. The cylinder made from steel and loaded with soil and the covering grass was tough to move. It was heavy and took physical effort to open and close the hole. There was a lot of speculation about what we would find buried in the ground. After all, as reclaimed land, there should not be any surprises. Yet, given the history of Oil Street Art Space, there could have been many surprises waiting to be excavated. We rolled the 2.5-m diameter steel tube to the side. There was a 600-mm deep hole. Three large yellow stones were laying on the ground. One of the three stones was carefully wrapped in a plastic bag made from red, blue and white plastic ribbons. There were some leaves on the ground. The hole was silent. My son Oskar, together with his friend Ella, decided to throw small stones into the hole. The stones landed on the wet and muddy ground. The stones were not from Hong Kong.

The second cut was easier to open. The circular opening of the barely 1-mm thick corrugated steel operated like a sliding door. I opened the wall and saw a couple of construction workers looking through the cages containing their yellow hardhats and equipment. I waved. There was no reaction. I think they were not expecting to be looked at through their storage cages. But maybe I did not realise that I was being looked at. A steady stream of construction workers came through the security barrier directly opposite the incision, all wearing their yellow hardhats, all heading home from their shift. The next shift was arriving, unlocking the cages to retrieve their safety equipment and to continue building the next extension of Hong Kong into the sea.

2.5米直徑的鋼管滑到一邊，揭開600毫米深的洞。有三塊大的黃色石頭在地上。其中一塊裝在一個由紅白藍彩帶織成的膠袋之內。地上有一些樹葉。洞是沉默的。我的兒子 Oskar 和他的朋友 Ella 把小石子扔進洞裏。石頭落在潮濕的泥土地上，它們不是來自香港。

第二個切割洞更容易開啟，1毫米厚的圓形波紋鋼板像拉門一樣打開。我拉開牆壁，看到一些建築工人正從擺放黃色安全帽和設備的籠子後面看過來。我揮手，他們沒有反應。我認為他們沒預期有人會通過他們的儲物籠觀看他們，但也許我沒有意識到我也被觀察？建築工人員源源不絕地從切割洞對面的保安閘走出來，他們戴著黃色的安全帽，準備下班回家，而下一班工人又陸續到達，他們打開籠子取出他們的安全設備，繼續把香港伸延到海洋。

油街實現的展覽於2018年4月22日結束。作品的拆除工程，揭示了精心製作的金屬結構如何移動1.5噸以上的泥土。這結構被切成小塊，並送到附近的堆填區。那三塊黃色石頭在香港大學美術館的《慢‧藝術日》作短暫展出。他們與一塊曾被香港大學校長收藏的供石一起展出和對話。草坪用原來的泥土重鋪，看來沒有甚麼改變。那扇圓形的窗將保留到大廈的工程完成為止，另一邊的工人已用紅白藍膠帶製造的物料覆蓋了那個洞的一部份。

The exhibition at Oil Street Art Space closed on the 22nd of April 2018. The removal of the works revealed the elaborate metal construction that made the movement of over 1.5 tons of soil possible. It was cut into pieces and sent to a nearby salvage yard. The three yellow stones made an appearance at the University of Hong Kong Museum and Art Gallery on Slow Art Day. They were set in conversation with a scholar's stone, previously held in the collection of the Vice Chancellor of HKU. The lawn was reconstructed using the original soil. Nothing appeared to have changed. The cut circular window will remain until the construction of the skyscrapers behind it is finished. The workers on the other side have partially covered it with a plastic sheet made out of blue, white and red ribbons.

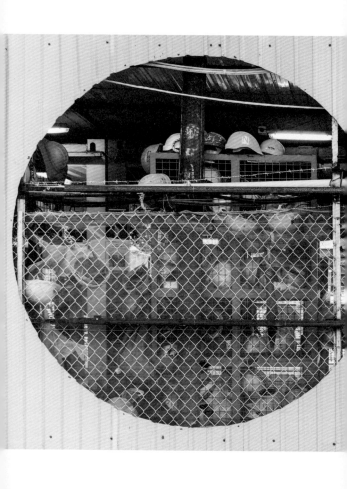

Interview with Mr Alfredo Wong
25 April 2018

T: Tobias Klein A: Alfredo Wong

01

T: Today, after our conversation, you will dismantle the work and literally cut it into pieces to be transported to a salvage yard. Sitting now in front of the excavated steel construction, I wonder what role this work has played in the 47 years, which your company, Singard, has been involved in building experimental installations for the stage. Which of your many projects is most similar?

A: Over the past 30–40 years, I have worked on many things. Every project is something new. My job is always interesting. We work very hard, and we never work on things that are not enjoyable and interesting. *CUT & SEA* was no different than our other projects—hard work that is enjoyable, new and interesting.

02

T: Does it make any difference working with an architect or artist?

A: Working with an architect was in many ways different. Working with artists is easier. They usually just provide a few drawings and sketches, or a general concept. They don't know how to make formal plans. We then make the design,

與黃宇正先生的訪問
2018 年 4 月 25 日

T: Tobias Klein　　黃：黃宇正

01

T: 感謝黃先生答應接受有關《揭視點》的訪問。今天，在我們交談結束後，你會把作品拆除並把它切成碎片並運到回收場。坐在挖空的鋼結構前，我想知道這件作品對於一間為舞台設計製作試驗性裝置 47 年的公司—羨園工程公司的角色。以前你有做過類似的作品嗎？

黃: 在過去的三四十年裏，我製作了很多新的東西，然而，我並沒有像工廠一樣大量製造單一產品。每一個項目都是一個新的項目，所以我的工作總是很有趣。我們十分努力工作，但我們從不創作一些我們不享受和無趣的作品。《揭視點》與其他作品一樣，都是努力做一些我們享受、新穎而有趣的事情。

02

T: 跟建築師一起工作和跟藝術家一起合作會有甚麼不同？

黃: 跟建築師一起工作有很多方面的不同。跟藝術家一起合作較容易，很多時他們會提供一些圖紙和

retaining the concept and the qualities described in the drawings and sketches. Often, after we finish the job, the result is exactly what the artists had planned for the work, and sometimes it is even better than what they had imagined.

Of course, working with an architect is a lot more trouble than an artist. (He laughs) You brought 36 pages of detailed plans, so we had to work systematically through everything, and follow your drawings. We learned some things and we changed other elements during our discussions with you and Yasu.

T: In your experience, if I would have given you only sketches, would you have done anything differently.

A: I would have done the same. (Laughs)

03

T: While working on the two incisions, the vertical and horizontal, do you think these two directions make sense in the space of Oil Street, or do you think they are alien to the square and the space?

A: They work very well within both the square and the space. They remind me of my career building stage designs for the theatre; they are similar— they make good use of the square space, transforming it into a stage.

04

T: In hindsight, would you change the construction of the two elements?

A: Not really, but I might want to change the setting of the rolling steel planter. The reason is the rail; if we were to make two rails with a tube

草圖或是一個概念給我們，但不知道如何製作，我們會保留其概念去設計，按照圖紙所畫和草圖中描述的質量去製作。很多時候，我們完成的結果正好符合藝術家所想，甚至有時會比他們的想像做得更好。

當然跟既是建築師又是藝術家的人一起工作會有更多的麻煩（他笑了）。你提供了36頁的細節並需要我們每一步都依照你的圖紙去製作。我們了解後跟你和金田先生一起討論提出改動。

T：根據你的經驗，如果我只給你草圖，你會用其他方法去製作嗎？

黃：我也會這樣做（笑）。

03

T：製作這兩個切口的過程中，一個是垂直的，一個是橫向的，你認為這兩個方向在油街藝術空間內有意義嗎？或是你認為它們疏遠了廣場和身處之地？

黃：它們在廣場和空間是十分理想，令我回想起自己從事劇場舞台設計的時候，二者很相似，它們的空間感很好，且善用了廣場，把作品轉化成一個舞台。

04

T：事後看來，你會改變製造兩個作品的方法嗎？

黃：應該不會，可是我會改動那個鋼造的裝置，原因是那個軌道。如果我們將兩條路軌都放上圓通，可以減小摩擦力，這樣會變得更好，同時它會變

on top, we would reduce the friction. That would be better. At the same time, it would be faster, and could easily cause an injury. So, I think it might actually be a good compromise that you have to really push it. It is hard to satisfy all parties.

T: A result of that heaviness is another layer of balance between the vertical and horizontal. The vertical fence is very light, just the thin surface of the corrugated metal. It is very easy, almost too easy and too light, and the horizontal is very heavy, so you have to really push the earth and steel—almost like a balanced conversation.

05

T: We met regularly with Yasu Kaneda, a structural engineer, to discuss the project and the construction. I very much enjoyed these meetings. Your experience and Yasu's ability to calculate the structure and my own way of detailing the elements seemed to work well. Was this a new process for you?

A: My son Anson is a structural engineer. We have worked on some projects together, including the work for your colleague Bo Zheng. Although structures generally require some calculations, to my mind, experience is more important. Sometimes calculations can become excessive. If you always need to do calculations, it wastes a lot of time. Experience always speeds up a project.

06

T: So what makes a good project?

A: Normally, we work on installations that aren't meant to last very long. In theatre stage design,

得更快，或許令人更容易受傷。我想現在的做法是一個好的協調，你需要用力推動它。現實是很難滿足到各方面的要求的。

T: 介乎垂直和橫向之間，結果產生一種沉重感覺的另一層平衡。垂直的圍欄十分輕盈，只是一塊波紋的薄金屬。這非常容易，幾乎太簡單和太輕，橫向卻很重，所以你必須推動泥土和鋼鐵，這就像一個平衡的對話。

05

T: 我們定期跟結構工程師金田泰裕會面，討論這個項目和施工。我十分享受這些會議，當你的經驗遇上金田泰裕的結構計算能力和我自己一套設計細節的方法，看起來這次合作十分順利。這些對你來說都是新的經歷嗎？

黃: 我的兒子 Anson 是一位結構工程師。我們一起完成過一些作品，包括為你的同事鄭波製作他的作品。儘管這些項目需要計算結構，但從我的角度來看，經驗是更為重要，因為有時候計算是不必要的。當你每次都需要計算，便會浪費很多時間。經驗會幫助你將工程進行得更快。

06

T: 所以要怎樣才做出一件好的作品？

黃: 一般來說，我們所做的作品都不會放置很長的時間。在舞台設計上，我們要牢記大部份的東西都只是暫時建造的。因此，視覺上的衝擊以及一個安全和穩定的運作是非常重要。如果一個作品達到以上兩點，那麼這個作品就可以了。要真正成

most elements are temporary constructions, and we have to keep this in mind. Therefore, the visual impact is very important, and of course a safe and stable operation. If both of these conditions are met in the project, then the project is a success. The most important point is the ability of the artwork to be unique. People should not have seen something like it before. If a project manages to be unique—like this project—that is the best result.

07

T: So, which of the two installations satisfy your criteria? Which of the two works do you like better, and why?

A: The fence was easier to make. If I had to choose one, I prefer the horizontal excavated lawn. It is unique. As I am retiring soon, it will be one of my last projects. A good project!

T: Thank you Alfredo for your time and for all of your help with *CUT & SEA*.

Mr Wong gets up and takes tools from his van. A couple of minutes later this 70-year-old man, together with his two helpers (both not a day younger), start to use angle grinders to dismantle one of his final projects. It was an honour working with him.

為一個好的作品，這兩點只是基本要達到的作品要求。在我心目中最重要是能令作品變得獨特，作品一定要獨特以及是其他人沒看過的。如果一個作品有獨特性，像這次作品一樣，那就是最好的了。

07

T: 那麼兩個作品中哪一種滿足您這個高標準？你較喜歡哪一個？為甚麼？

黃: 圍板上的那個製作較容易。如果要我去選擇，我較喜歡橫向挖空泥土的那個。它很獨特和非常特別。我差不多退休了，這將會是我最後的作品之一，一個很好的作品！

T: 感謝黃先生付出的時間和所有為《揭視點》的幫助。

黃先生站起來，從他的車上拿工具。幾分鐘後，這位70歲的男子連同他的兩名助手（兩人不比他年輕多少）使用磨機，開始拆除裝置的工作。這可能是黃先生其中一個最後的作品，能與他一起工作是一種榮幸。

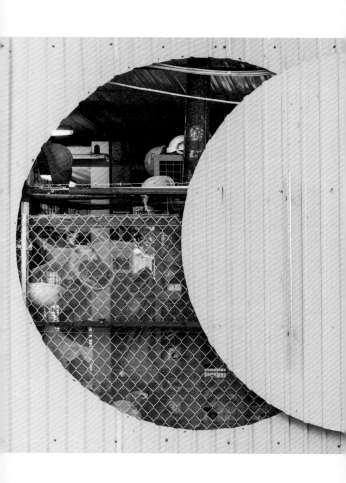

Interview with Mr Yasuhiro Kaneda
25 April 2018

T: Tobias Klein Y: Yasuhiro Kaneda

It is 12:30. In the background, Mr Wong is dismantling the steel structure. His two colleagues use angle grinders to cut the large steel elements into movable pieces. Yasuhiro Kaneda is a trained structural engineer I hired to assist with the project, specifically with the calculation of its static and dynamic parts. We are sitting on an octagonal bench beneath one of the large trees in the courtyard of Oil Street Art Space, watching the work disappear into a fiery shower of sparks. Though destructive in nature, it is a calm background for our conversation.

01

T: Yasu, thank you for coming today and for agreeing to share your views and experiences from the project. Before our interview, I spoke with Mr Wong and asked him a series of questions about the project and our collaboration. I will start with similar questions and we'll see where it takes us.

Y: Thank you very much for inviting me today, and thank you for being part of this project.

T: To begin the conversation, did this project provide any difficulties or challenges for you as an engineer, or was it almost too small for you— considering that you are a structural engineer?

與金田泰裕先生的訪問
2018 年 4 月 25 日

T: Tobias Klein　　金：金田泰裕

時間是下午十二時三十分，黃先生正在拆卸那鋼鐵結構。他的兩位同事使用角磨機把大塊的鋼鐵組件切割成可搬運的尺寸。我僱用了專業結構工程師金田泰裕協助我完成這項目，並計算作品的不動及移動部份。我們坐在油街實現庭院樹下的八角型凳，一面看着這作品在火花中消失，一面詳談。雖然目睹的是破壞性的畫面，但這過程為我們的對話提供一個令人感覺平靜的背景。

01

T: 泰裕，多謝你今天來到油街實現，與我們分享參與我們作品《揭視點》的過程與及你的看法。在這訪問之前，我已問過黃先生一系列有關這作品與我們之間的合作的問題，我也會問你相同的問題，看看有甚麼結果。

金: 謝謝你今天的邀請，也感謝你成為這香港作品的一部份。

T: 我們先打開話匣子，作為工程師，這作品對你來說有甚麼難度或挑戰，抑或對任職結構工程師的你來說，這項工作太小規模？

Y: I think the most difficult part of the work was setting the load conditions, because there is no regulation for this particular type of work. Buildings have very clear and strict regulations for all structural parts, and for all loading elements and scenarios—such as the live load, impact load, rain and wind loading. For this project, I was not able to follow any of those regulations. Therefore, I needed to establish scenarios, assuming the regular loading of natural forces such as the wind, as well as the possibility that people might, for instance, climb onto the installation. These scenarios forced me to assess the design and to recommend specific component sizes and mechanisms for the work to be operated safely for five months.

02

T: If establishing these scenarios was the most challenging part, which part of the project do you consider was the most successful, and maybe the most enjoyable?

Y: I think the purity of the project is its strength. By purity, I mean the ability to maintain the qualities of the conceptual design throughout the materialisation and technical production. Purity is being able to articulate a concept in a built design without compromising anything due to the technical realisation, or adding unnecessary complexity. I am quite happy that we were able to retain the overall concept of the views and directions—maybe even more than I expected. I couldn't imagine what kind of views would be created from here to the hole in the back of the wall. I asked myself what kind of feeling might be generated when looking down into the hole in the ground. It was very important that you were able to realize your concept without any changes,

金： 我想最難的部份是找出這作品的負重，因為沒有
條例監管這樣的作品。樓宇的各項結構部份和情
況都有明確和嚴格的條例監管，比如說活負載、
衝擊負荷、風雨負荷等等。我卻不能依照這些條
例量度這作品，所以必須建立不同情景，假設一
般自然環境如風力的負荷，再加入一些假設性情
況，如有人爬上這裝置之上會怎樣。這些情景讓
我得以評估設計，為作品推薦不同組件及機械裝
置，以便它能安全地展出五個月。

02

T： 若設計這些情景最具挑戰性，你認為作品哪部份
最成功，哪部份令你最享受？

金： 我認為作品的純度是它最大長處。純度的意思是
指在整個項目的製成和技術生產過程中，保持了
原來的設計概念。即能夠在完成的作品中表達設
計概念，不會由於技術的實現，或增加不必要的
複雜性，而令作品有所妥協。我很高興我們保留
了原來的觀點和方向——結果甚至超出了我的預
期。我原先無法預計由這個點到牆上的洞，可創
出甚麼樣的景觀，也無法想像俯視地面的洞會產
生甚麼樣的感覺。在實現這作品時，你沒有改變
本來的的概念，並保留了作品如何改變這環境的
理念，這一點非常重要。

至於這個項目的愉快之處——我很高興能夠和黃先
生合作，因為他是一位非常誠實和具豐富經驗的
五金工人。在設計會議期間，我從他身上學會很
多東西。我認為我們三人之間有很好的化學作用
產生，經常從不同的角度討論事情，彼此聆聽而

and with a clear vision of how it would change the space.

As for the most enjoyable part of the project—I am quite happy that I was able to work with Mr. Wong because he is a very honest and incredibly experienced metalworker. I learned many things from him during our design meetings. I think there was a good dynamic in the room amongst the three of us. We often discussed things from different viewpoints, listened to each other without compromising the overall project. In my experience, this is not always the case. Often, fabricators do not express their opinion, and can be rather passive during the design process, which does not create a dialogue, but rather a scenario in which the architect simply tells the fabricator what to do. In this project, you brought all of the parties together right from the start.

03

T: As we both have children that are about the same age, and who were both at the opening of the project back in December, how did you explain the work to your daughter?

Y: I really enjoy the two directionalities of the project. When I look at your project, I see two timelines emerging and extending into two directions. One is the past. We look back into the past. In your work, we look down into the ground and see the past of Hong Kong. Even opening and spending the effort to move the planter, we make an effort to look down into the past. The second one is the future. When we open the incision into the wall, we are looking at the horizon. As the world turns, we can see the sunset in the distance, so we look into the future of what is to come. Lastly, the present moment

不影響整體項目。根據我過往的經驗，這種情況不是常常出現。一般技術人員不會表達他們的意見，而且在設計過程中頗被動，這不利於建立對話，通常是建築師告訴建造商應怎麼做。在這個項目，你一開始便把所有參與者聚集在一起。

03

T: 我們都有差不多年紀的孩子，他們都有出席去年12月的開幕典禮。你如何向女兒解釋這項目？

金: 我真的很喜歡這個項目的兩個面向。我看到你的項目時，了解到是兩個時間軸出現並延伸到兩個方向。一個是過去，我們回顧過去。在你的作品中，我們低頭看看地面，看看香港的過去。我們用力打開那花糟時，也努力回顧過去。第二個方向是未來。當我們打開牆壁切口時，可看到地平線。隨着地球轉動，我們可以看到遠方的日落，也可從中看到未來。最後，現在是通過未來和過去之間的雙重性構建出來。我們站在現在這一刻，不斷打開或關閉這兩條時間軸。

T: 但你會向你女兒解釋這作品嗎？可以嗎？

金:（笑）或許可簡單地告訴她這個洞可看到將來，那個洞可看到過去，而我們活在現在。這個作品顯示時間和它對我們的意義。

04

T: 泰裕，謝謝你。早前我也問黃先生他較喜歡哪件作品和原因。你呢？你認為哪件作品較好，對你來說較有意思？

is constructed through this duality between the future and the past. We are standing in the present, operating both timelines by opening or closing them, literally.

T: But would you explain the work to your daughter like this?

Y: (Laughs) Maybe it is as simple as telling her that this hole is there to see the future, this hole is for seeing the past, and we are living in the present. The work shows time and what it means for us.

04

T: Thank you, Yasu. Earlier I asked Mr Wong which of the works he likes better and why. In your opinion, which is more significant?

Y: When looking at the project, I think about the directions of the timelines, and also about the directions of communication and about the object and observer relationship. To start, behind the wall there are many people doing something, coming to work or leaving after their shift ends. When you open the wall and make this mundane process visible, framed by the circular opening, the workers become actors and, to a certain degree, objects. Although, standing here, they seem not to look back or to observe us—maybe they are. I have not been to the other side; it might be amusing for them to see this side and how we stare at them. Even more so with the work on the ground, I wanted to be the object, maybe one of the stones, and to see the world from the object's point of view. I imagine that I would lay down on the ground and we would close the lid. After a while, somebody would open the structure. What would I see and feel, looking up into the face of a visitor confronted with me

金： 當我看這作品，便想到時間軸的方向，同時又想到溝通的方向和觀看者與被看者的關係。最初在這牆的後面有很多人在做些甚麼，他們到來工作或工作完畢後離開。當你打開這牆，把這平凡的一面通過圓型的窗戶曝露於人前，讓工人變成演員，在某程度上更成為物件。雖然他們站在那兒，沒有望向或觀察我們，也許他們有也說不定。我沒到過另一邊，可能對他們來說望向這一邊，看到我們瞪着他們也頗為有趣。地下的那個作品更甚，我想成為被觀察者，也許是其中一塊石頭，從這角度觀看世界。我想像躺在地上然後關上蓋子。過了一段時間，有人會打開蓋子。當我看到訪客看見我躺在地洞裏，我會看到甚麼和感覺到甚麼？若能拍攝他們的反應和捕足其臉部表情，必定會很棒。

T： 我明白你的意思了；我創造了一幅活人畫，一幅有畫框的活畫。把演員顛倒成為觀察者，是個有趣的體驗。另外，延續你水平和垂直時間軸的閱讀，變成歷史觀察我們，在牆上的作品而言，則是未來觀察現在。這閱讀很有力量，泰裕，謝謝你！

金： 我認為這作品非常有趣。它像一張畫，但把這概念一直延伸，可以從另一邊獲得另一視點，或者想像這視點是甚麼。這個觀點就像——看着你自己。謝謝你，Tobias。

我們從凳上站起來。黃先生和他的兩位同事差不多已完成了拆卸。明天，園藝公司將把草坪恢復原狀。

in the hole? It would be great to film people's reactions.

T: I see what you mean; it became a *tableaux vivant*, a framed painting that is actually alive. Reversing this notion of the actor becoming an observer would be an interesting experience. Additionally, if I take your reading of the timeline created by the horizontal and vertical, it would be history looking back at us, and in the case of the wall, the future observing the present. That is a powerful reading! Thank you, Yasu!

Y: I think that this is a key point of the project. It works like a picture, yet extends this notion, as you can have the point of view from the other side or you can imagine what it is. The view becomes like looking at yourself. Thank you Tobias.

We get up from the bench. Mr Wong and his two colleagues have almost finished dismantling the work. Tomorrow the landscaping company will restore the lawn.

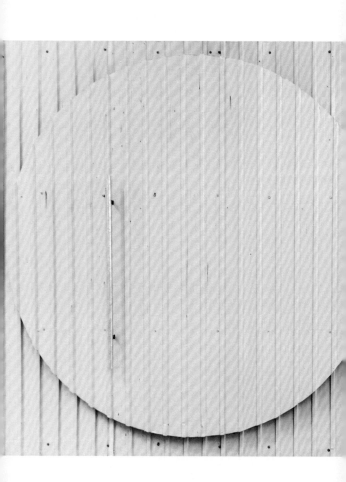

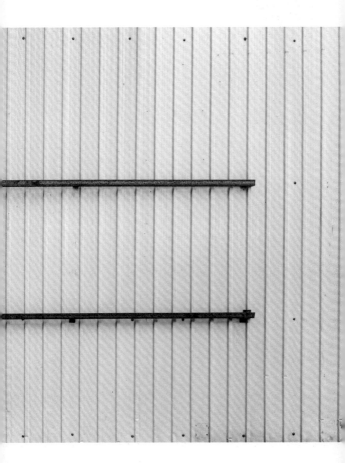

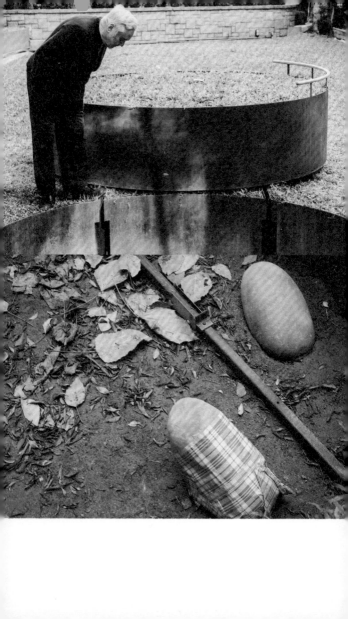

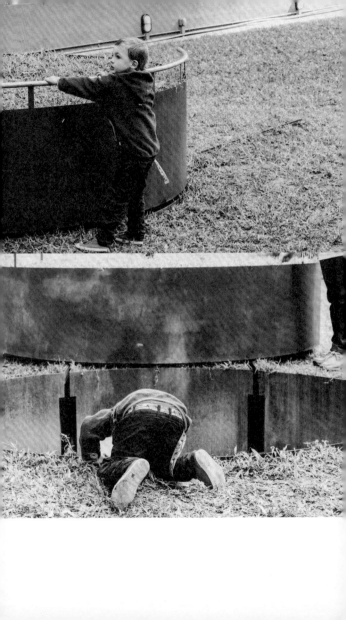

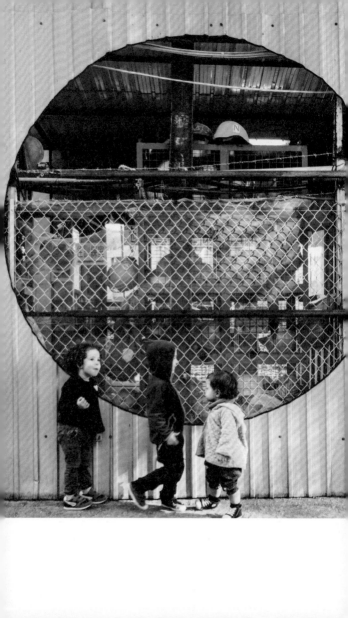

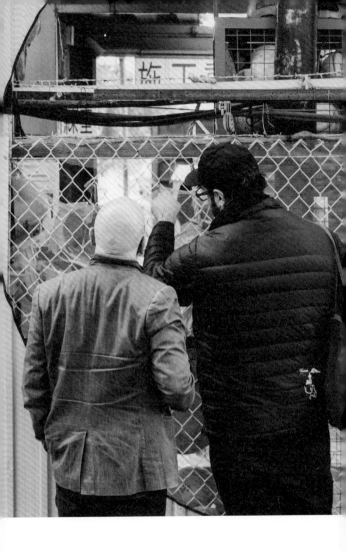

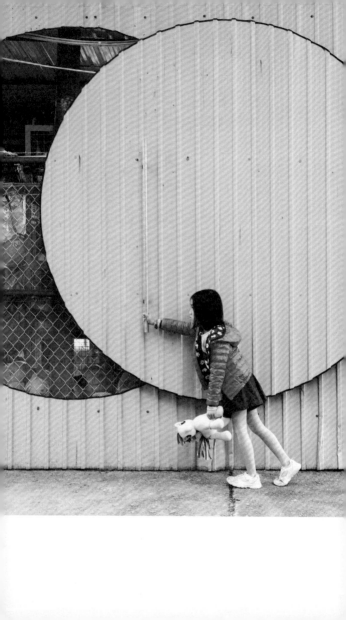

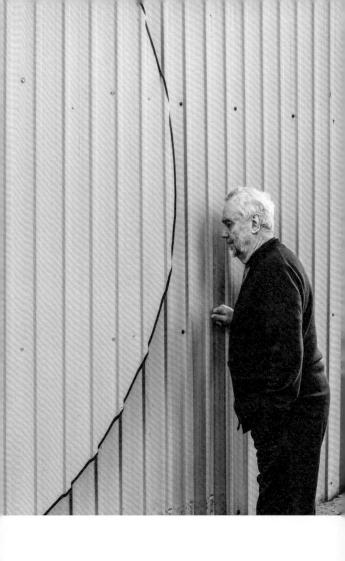

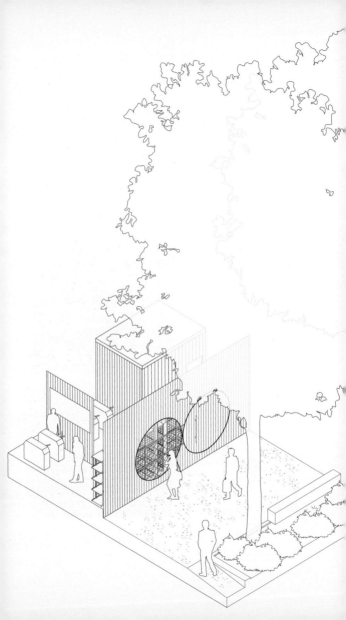

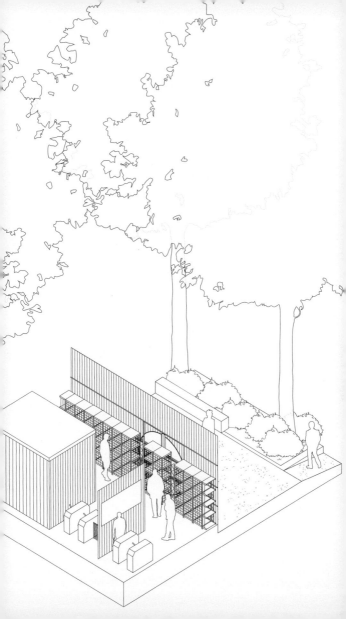

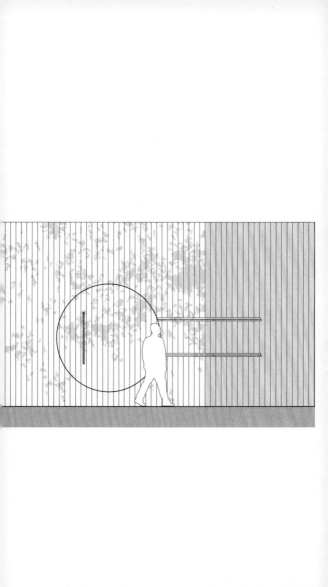

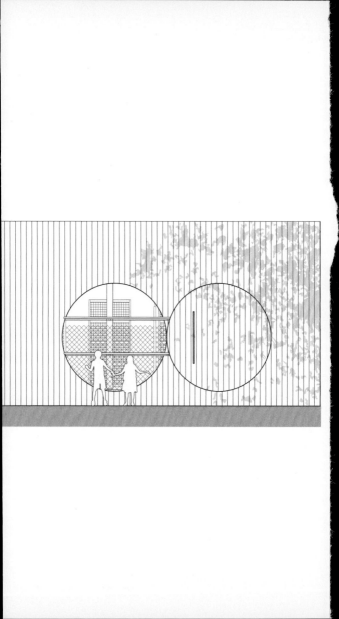

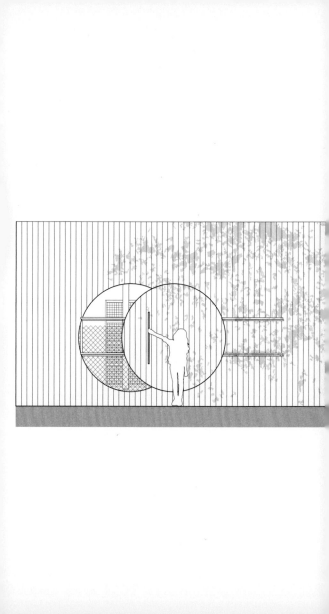

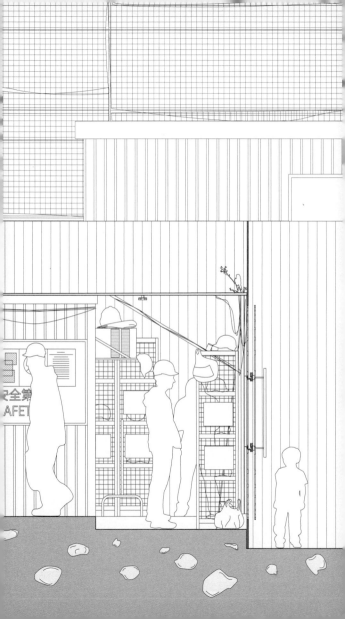

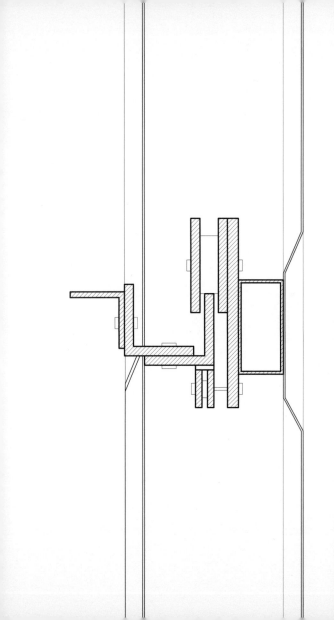

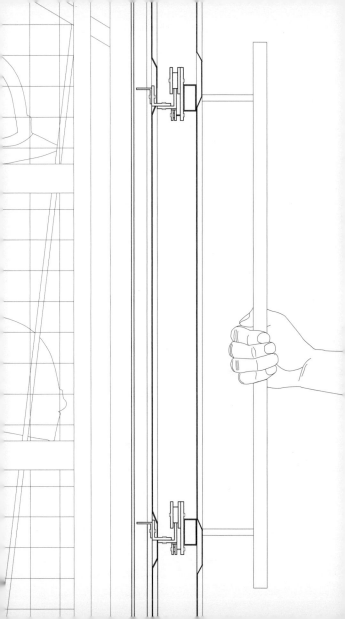

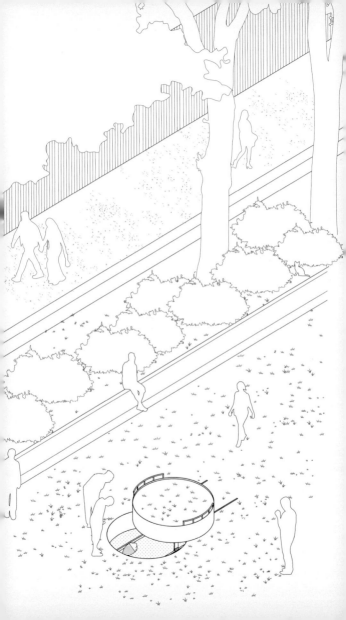

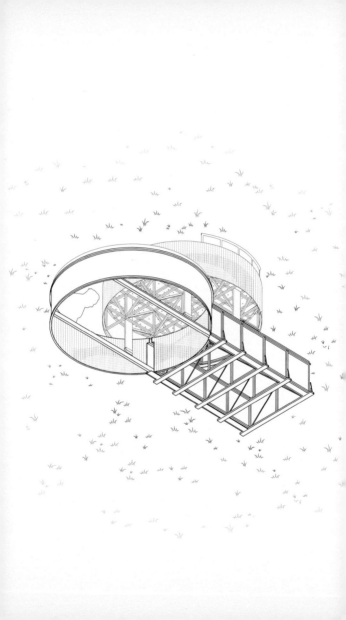

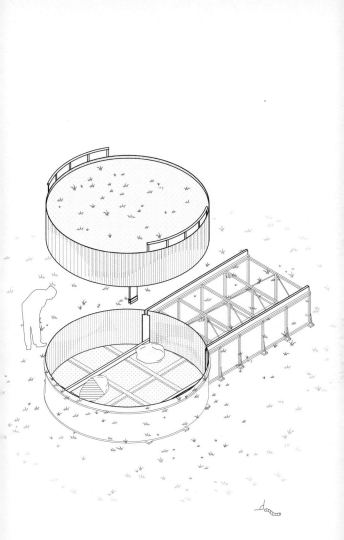

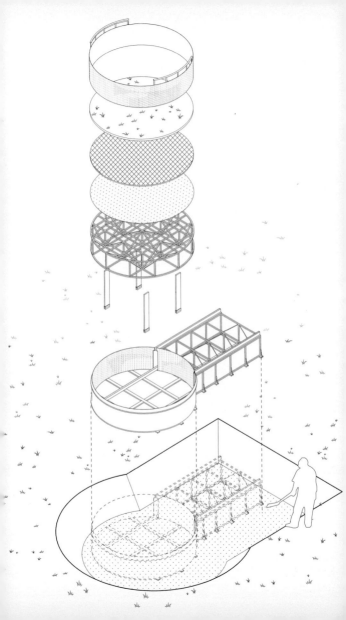

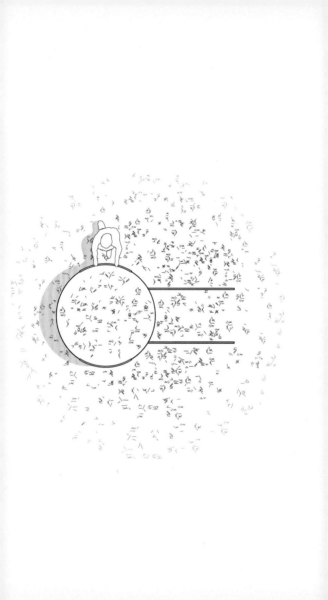

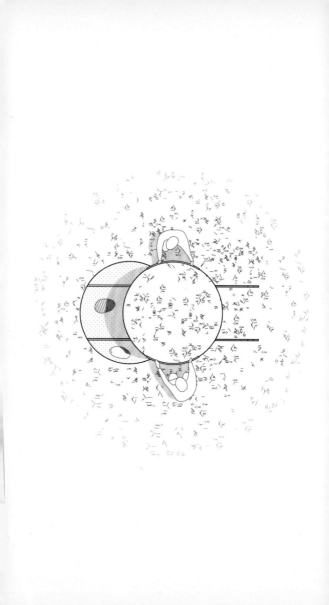

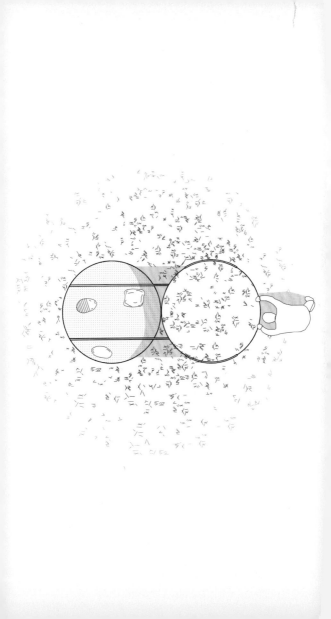

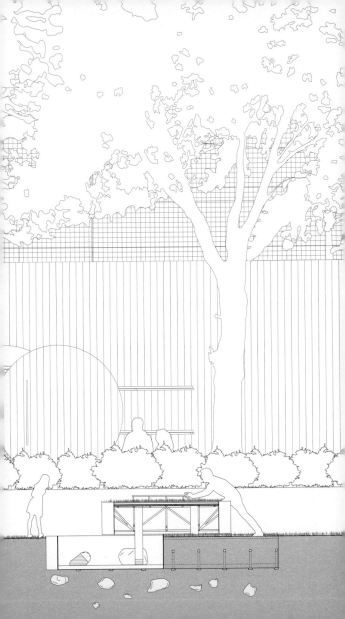

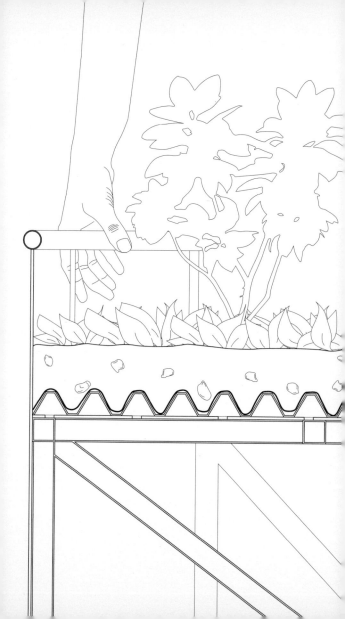

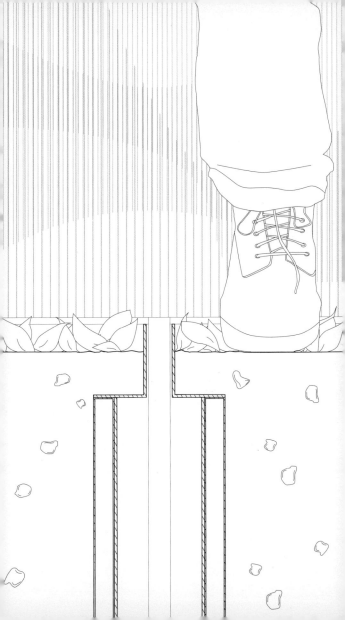

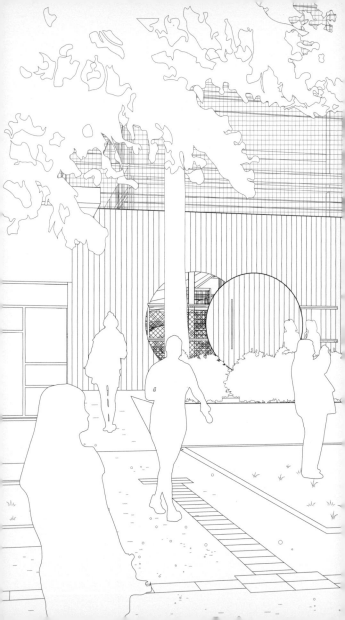

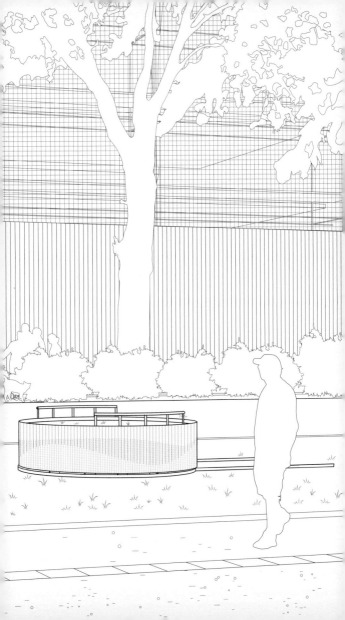

Tobias Klein's Manipulative Stage for Unsettling Visitors

Harald Kraemer

Fortress Hill. Where the towering waves of the South China Sea once washed over land for thousands of years. Today functionally-decorated towers form the city's new liquid face. In the midst of this urban landscape emerges artificially constructed nature in the form of parks. Visitors are looking for a moment of peace and quiet before they rush from triviality to insignificance. The wilderness—so near and yet so far—remains as alienating as the memory of the water.

In the midst of this scenery, Tobias Klein has placed his latest work *CUT & SEA*. Placed is the wrong expression. He cuts it in, cuts it through, cuts it down. Brutal and strange. It appears that this work doesn't account for, and at first glance has no respect for, the pre-existing neighbourhood. This radical cut articulates the artificiality of its existence. It becomes all the more painful. How does the work succeed in establishing this construct of disturbance? The set-up is clear. There is a large steel disc on a fence and another large steel disc on the ground. For the sake of simplicity we refer to them as vertical and horizontal. Both discs are exactly the same size. Both can be moved back and forth. Depending on which position they occupy, they close or open a 2.5-m circular cutout. The incision into the ground documents the soil, the earth. The other, depending on where and how you look, shows fragments of buildings, a restful meadow, a moment of sky, a slice of heaven.

Yet the work is not simplistic, because an essential part of understanding this incision is the place

Tobias Klein 經營令
訪客失措的舞台

孔慧鋭

炮台山，曾經一直被南中國海的浪濤沖刷數千年。時至今日，已大廈林立，成為城市中心。城市的中央出現了大大小小的公園，那是人們在繁瑣和匆忙的生活中獲得平靜和喘息的空間。而那似近若遠、曾覆蓋炮台山的海水會記錄着歷史的痕跡。

就著這個想法，Tobias Klein 在此地擺放了其最新的藝術裝置《揭視點》。但「擺放」此詞似乎並不精確。他是把作品「切入」土地——是穿透，是陷入，野蠻且怪異。一瞥之下，你或會認為已存在的社區環境並非作品的考慮因素，那「不假思索」的插入並沒有尊重社區的原有特色，只帶來了痛苦。那插入作品的目的是為了干擾社區嗎？作品的設置清晰——圓形鋼板一個置設於圍欄，另一置設於地上。為方便起見，簡稱為一直一橫。兩者面積相同，皆可向前後移動，可閉合或開出一個2.5米的圓形切口。裝置會記錄泥土和土地的變化，而視乎在不同位置和角度觀察裝置，通過切口，可以見到高樓的碎片、休憩的草坪、剎那的天空和一片的天堂。

然而，這作品並不簡單，要理解這切口，便先要明白介入發生的地點。這地僅數十年前還臨近海岸，並設有遊艇碼頭，但現在一切已消失，土地早已吞噬海洋。街道的名字喚起這裏原是海邊的記憶，老一輩的街坊也許仍記憶猶新。像這樣的地方，香港有很多很多，現在

where the intervention happens. There, where only a few decades ago the shore was located, a marina, little now is felt. The land has long swallowed the water. Street names suggest this original location on the shore. And some of the older residents may still remember. At one of these sites, of which there are many in Hong Kong, now exists an encounter between two opposing poles. Whether it is a dialogue or a confrontation should remain open at this point. First of all, it must be stated that this is by no means a passive and lifeless form of public art. The two-part work is far from being just another inconsequential, loveless and unfamiliar place decoration. An artfully designed tease set against our cityscape. Rather, with his intervention into the public space, Tobias Klein offers a stage to discover, explore, experience and play. And the visitor who comes to this place must get involved, must develop a willingness to experience the work as such. There are no major instructions on what to do, just an open invitation. At the same time, if the visitor decides to be only a bystander, the explosive power of the work remains. Though only if the visitor chooses to become an actor is the work truly transformative; otherwise the experience remains without consequence.

The vertical as well as the horizontal are independent, yet parts of a whole. They demand action. The viewer becomes the actor and is invited to move these two poles. If we take the extreme states of the range of movement and possibilities, and focus on this observation, then the horizontal and the vertical each have two states that can be called opened or closed. Or visible and invisible. Or light and heavy. Both works also play with the charm of the unknown, with the desire to discover what lies behind and with the compulsion to explore.

The movement of these two discs can be playful. We encounter numerous variations within the extreme states of being opened or closed.

是兩個相反方向的交匯點，在這階段是對話還是衝突尚未有定案。首先要說的是，這不是一件被動或沒生命的公共空間藝術品。這個由兩部份組成的作品也絕不是那種在我們的城市內常見的不相干、沒感情、陌生但設計精美的裝飾品。Tobias Klein 在公共空間的切入，給予到訪這空間的人們一個發現、探索、經驗和玩樂的舞台。訪客必須參與和願意經驗這作品。作品沒有附帶說明書，只有公開的邀請。同時，若訪客決定只當旁觀者，作品的爆炸性能量還是存在，但它只會在訪客選擇成為行動者時才會有轉化的作用，否則整個經驗都顯得微不足道。

直和橫的圓板獨立而設，組合為一個整體，但不會自動開合。變化和移動的產生取決於觀眾的行為，他們會被邀請移動圓板。假設作品不斷的移動和改變，相比靜止、或開或合的狀態，我們更能發掘作品的可能性——可見與不可見、輕與重。作品的趣味在於我們對未知的渴求，會迫使我們去一探究竟。

兩塊圓板的移動輕易又具玩味。我們實驗開與合兩極之間擁有多種變化。就如月亮的圓缺，這些變化可理解為新月或圓月與及中間的所有月相變化。作品這樣豐富不全是因圓板的完全開與合，而是中間的許多個瞬間，一次又一次地不斷創作出新的景像。

若作品閉合，我們會希望推開裝置看看內裏的乾坤，想像這巨大的圓板藏有甚麼。在好奇心的驅使下，觀眾會推開圓板，並發現裏面空無一物。最理想的假設是觀眾會因而反思自己對新事物和娛樂的追求和沉迷；最壞的情況是觀眾的好奇心無法被滿足，因而感到失望。另一方面，那打開了的裝置，就看似傷口一樣，在異

Almost like the phases of the moon, these states can be understood as a new moon or a full moon, with all of its variations. So, it is not only the extreme states of being either completely closed or completely open, but the many instants between that make the work so rich and create multiply repeating views.

If we find the disc closed, we want to see what is beneath and behind. We imagine what this massive disc hides from us and what we can discover. Driven by curiosity, we open the hole expectantly and discover, in the best case, the restless motivation of our search for the new, or else our eternal addiction to entertainment. In the worst case, we are disappointed because our consumer behaviour goes unsatisfied. When opened, it looks like open wounds, like foreign bodies in an environment in which they do not belong. Close the pit to prevent bad things. The cut through that must be masked to hide what lies behind. To create order, we tend to close openings. Everything has its order closed, and we are good at satisfying ourselves with appearances and denying reality.

The past is inscribed in the present and decisively influences our future actions. Whether a glass half-filled with water is understood as being half-full or half-empty says a great deal about our past experiences, and thus about the readiness of future decisions. The half-empty, as a symbol of what has already been revealed, passed through and lived, stands in contrast to the half-full, as the symbol of what is still alive, experienced and filled. How can this image be transferred to the state of the opened and closed discs? What has happened, what is present and what does the future hold? Given the conditions of opening and closing, there is no before or after. Only the actual state counts, because this is defined from the previous state and anticipates the coming. The non-simultaneity of the before and after is canceled. Only the here and now counts.

物無法找到所屬。為了建立社會的秩序，防止壞的事情發生，人們或會將裝置合上。因為人們總是否定現實，並滿足於那個由他們建立的表象。

過去刻劃於現在之中，對我們未來的行為有決定性影響。我們視半杯水為半空還是半滿，取決於我們過往的經驗，也左右我們未來的決定。半空象徵已被發現、已過去和已經歷；相對半滿象徵着此刻活着、經驗和盛載。這形象能怎樣轉移至開與合的圓板之中呢？以開與合的情況來說，沒有所謂先與後，只有現在的狀況才重要，因為這狀況根據過去而定，同時又為將來作準備。先與後的非即時性被取消，只有現在這一刻才最重要。要了解這非同時發生的同時性，其中一個體驗隱藏在這多層次的藝術品之內。其他的對比如土地與城市，引發我們想起自然與人工。通過可看見與不可見，我們最終可拯救幻覺與現實。

作品的其中一個重要功能來自打開圓板後的發現。通過觀看圓洞另一面的隔鄰工地，觀看者轉移觀看工人的活動，這些都是工人日常的活動。這些活動過於普通，很難察覺到當中有任何進展，只有經過一定時間才可發現發展的趨勢，看到樓宇正逐漸變化。通過提供給觀眾一個顯微鏡般的視點來觀察日常重複的過程，Tobias Klein 創造了一個了解日常活動作為不斷改變的過程的先決條件。觀察者可以說為香港無處不在和四處蔓延的建築狂熱的縮影作註釋。在另一面的建築工人在這風罩的不斷開啟與關閉而被打擾，從而意識到他們成為了被觀察的對象。建築工人如何理解這行為上的「滋擾」有待證實。那個平放的圓板是另一類型的發現，它處於開啟的位置時可看到三塊較大的石頭，這些石來自

In understanding this simultaneity of the non-simultaneous, one of the experiences to be made is hidden in this multi-layered work. Other contrasting pairs—such as the land and city—leads us to the natural and the artificial. Through the visible and the non-visible, we finally come to the rescue of illusion and reality.

A crucial role in this work centres on the discoveries when opening the discs. Looking through the vertical opening into the neighbouring construction site the observer becomes an observer of the workers' activities. These are everyday routines that can be observed. The repetitive activities are so commonplace that little progress is registered. Only over a period of time is progress made in the development of the building visible as a form of change that has taken place. By offering the viewer a type of microscopic excerpt from a repetitive daily process, Tobias Klein has created a prerequisite for understanding everyday activity as a continuum of change. The observing observer becomes, so to speak, the chronicler of a microcosm of the all-encompassing and proliferating construction craze in Hong Kong. On the other side are the construction workers, who, through the opening and closing of the screen, are repeatedly interrupted in their actions by becoming aware of being the object of observation. How the construction workers perceive this performative 'disturbance' in their daily lives must remain open at this point.

The discovery to be made with the horizontal disc is something completely other. Here, in the open state, three larger stones become visible. The stones themselves come from the Yellow Mountains (Huáng Shān). These stones have never been found on the shores of Hong Kong, and they seem like strangers, as if they are in the wrong place at the wrong time, one of them hiding in a plastic bag with the typical Hong Kong red-white-and-blue pattern. The stones give rise to a mystery

黃山。這些石塊從沒在香港的海岸出現過，它們像是陌生人，就像在錯的時間出現在錯的地方，其中一塊隱藏在香港典型的紅白藍塑膠袋內。這石塊在此地出現，引發了一種令人不安的神秘感，這些石頭不應出現在這地方，但卻像一直已在這兒。在兩者的差異之間，我們可觀察到改變的本質。我們一般相信可影響短期的改變，但改變受很多因素左右，我們只能接受而不能真正引導或影響改變。石塊象徵大自然是藝術家和雕塑家，每天孜孜不倦地逐小改變世界，有時會帶來翻天覆地的巨變。我們當中一些仍保持禪宗般和諧的人，就如洞裏這幾塊石頭，意識到謙卑和崇高。

建築工人的觀察性視點和他們的行為，與及三塊石的出現，必須被理解為一種基本的敘事概念，藝術家將觀眾融入更大的敘事線中。訪客的行為與觀察者、發現者和演員角色變化的認知，構建着一個交叉的氛圍。作品的位置令它變成一個表演作品，把場地變成了舞台。只有通過他們的參與，演員才能意識到自己已成為作品的一部分。若沒有他們的演出，這作品只是一個精心設計、放置於地上的物體和在公共空間內的一件牆壁掛件。然而與此同時，Tobias Klein 的作品還包括刻劃人們面對必然改變時的無力感。

關於作品的兩極性與所在場域的關係，顯然更為複雜。如以古今相鄰的海岸和透過奪取海洋領域而建的社區為例，這片土地和城市連接着自然和人為的景觀，在可見與不可見的事物間，最終會發現虛幻與現實。這平衡的狀態與作品的結構互相呼應——垂直透光與橫放黑暗的缺口。作品的結構和圓板的開合狀態與「陰陽」的哲學有關。「陽」泛指向上、天和男性；「陰」泛指橫

at this locality and unsettle us. They are out of place and seem to have always been here. In this discrepancy lies an observation about the nature of change. We tend to believe in influencing change in the short term. Yet change is subject to everything and can only be accepted by us. It is never guided or influenced. The stones symbolise that nature itself is an artist, a sculptor who everyday tirelessly acts and shapes the world gently, and sometimes eruptively. Those of us who remain zen-like in their silent harmony, like stones in this pit, become aware of humility and sublimity.

Both the observational view of the construction workers and their actions, as well as the discovery of the three stones, must be understood as being an essential narrative concept with which the artist incorporates the viewer into a broader narrative arc. The actions of the visitor and the becoming awareness of the changing roles as observer, discoverer and actor constructs a superimposed context. The location of the work becomes a performative piece and transforms the site into a stage. It is only in their participative actions that the actors learn to understand themselves as constituents of the work. Without their work, it would simply be a finely designed floor object and a wall object in a public space. At the same time, the work of Tobias Klein includes a recognition of the powerlessness of one's own actions in the face of the change to which we are all subject.

Returning to bipolarity and the place where the work was created, it is apparent that much more hides behind this aspect of bipolarity. If, for example, we take the pair of sea and land to mark this particular place wrestled from the sea, then past and present are never far away. Land and city, on the other hand, would lead us to a natural and artificial appearance. Through the visible and the invisible we finally arrive at illusion and reality. In its balanced nature of the bright void of vertical openness, and the dark void

向、地、洞穴和女性。作品其實有三個部分：一、直和天；二、橫與地；三、人類作為推動的因素。因此之故，《揭視點》隱含着天、地、人合一的古代觀念。

此外，透過觀察橫直的方向變化，組合成四個座相，每一座相皆引領我們到不同的方向。當兩塊圓板緊閉，陰陽便無法在這閉合空間流動。若垂直的圓板關閉，橫放的圓板打開，「陰」便佔主導地位，反之亦然。若兩者皆打開，「陰陽」便可流動轉化。過程將產生多於四種狀態，將引領人們與裝置互動。此時，人類便是連結天地傾權的導體，讓天、地、人達到和諧或差異的狀態。

Tobias Klein 在這片透過奪取海洋領域而建的土地上製作藝術裝置，讓天、地、人和他們之間的關係變得清晰可見和能被觸及。雖然海洋不再掩蓋此地，但只要海水曾流過此地，它就能牢牢記着它曾屬於這裏，因為它的記憶是永恆的。而身處此地的我們也看見海洋，「海洋」正正意味「看見」。Tobias Klein 提醒我們一剎那的行為，結果卻是永恆。

of horizontal openness, the work can be related to the philosophy of Yin-Yang. The actual opening and closing of the discs remind us of this. Here, Yang corresponds to the vertical, to the sky, to the male; whereas, Yin corresponds to the horizontal, that is to the earth, to the cave, to the feminine. But actually the work consists of three parts. First, a vertical or the sky. Second, a horizontal or the earth. And third, the human being as an acting element. Thus, behind *CUT & SEA* hides the ancient idea of the trinity and the unity of heaven, earth and man.

Moreover, for the observer, four constellations result from the possibilities offered by the construct of horizontal and vertical. Each of these constellations leads in a different direction. When the vertical and horizontal are locked, a closed space is created. Neither Yin nor Yang can flow. If the vertical is closed, but the horizontal is open, the energies of the Yin predominate; conversely, the Yang becomes stronger. And if vertical and horizontal are open, both flow in dialogue. There is more than the four states. It is the moment of the in-between. This moment leads people to action. For as a connecting force between heaven and earth, man is responsible for shaping these forces in harmony or in discrepancy.

Heaven—Earth—Human beings and the relation-ships between them become visible and tangible with the incision that Tobias Klein has made in a site that has been torn from the sea. But the water still remembers what it once belonged to, because the water's memory is eternal. In this respect, the awareness of the place we are in also serves to see it. Sea means see. And with this painful cut, Tobias Klein continuously reminds us that although our actions are of a brief duration, the consequences of our actions very well may be final.

Picture taken on the occasion of Slow Art Day, 14th of April 2018, at the University of Hong Kong Museum and Art Gallery, showing in the foreground a calm conversation of one of the yellow stones of the *CUT & SEA* project with a scholar's stone, previously held in the collection of the Vice Chancellor of HKU. In the background is a similar conversation taking place between the work *MASK* by Tobias Klein and a wooden seated Buddha sculpture from the Ming dynasty. The exhibition was curated by students of the MA Curating Art & Media program of the School of Creative Media, City University of Hong Kong.

圖片是在 2018 年 4 月 14 日在香港大學美術博物館舉辦的慢速藝術日拍攝的，在前景展示了一塊 CUT & SEA 展覽中的黃臘石與一塊香港大學副校長前收藏的供石之間的平靜對話。背景是 Tobias Klein 的作品 MASK 和明朝的木製佛像之間的相似對話。該展覽是由香港城市大學創意媒體學院的藝術碩士策劃藝術與媒體展覽的學生策劃。

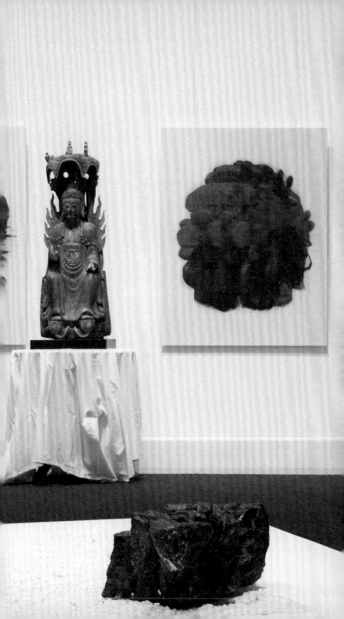

Acknowledgements

Hereby I would like to thank:
Richard W. Allen, Maurice Benayoun, Kurt Chan,
Jennifer Chu, Carol Chung, Kyle Chung, Simon Chung,
Isabelle Frank, Scott Hessels, Vicky Ho, Daniel Howe,
Yasuhiro Kaneda, Kikki Lam, Judy Law, Olli Tapio Leino,
Pok Yin Leung, Agnes Lin, Christopher Mattison,
Peter Nelson, Fion Ng, Kai Fung Ng, Max Tsoi,
Tamás Waliczky, Hanna and Tapio Wirman, Marco Wong,
Yu Ching Wong, Joseph Yiu and Bo Zheng.

I would like to especially thank Ivy Lin (Oil Street Art Space),
Almuth Meyer-Zollitsch (Goethe-Institut Hong Kong) and
Florian Knothe (Hong Kong University Museum and Art
Gallery) for their generous support and for the opportunity
to show my work in their institutions.

Furthermore, I would like to thank my research assistant
Sze Chun Hui, Kelvin, for his outstanding work on the
drawings, photos and in the organisation of this publication.

Last but not least, I wish to thank my friend Harald Kraemer
for our fruitful exchange of thoughts and his inspiring
criticism.

To my family – Anneli, Oskar, Lina – a very big thank you;
as well as to Ute, Anna and Erich for their help.

Tobias Klein. CUT & SEA

This book is published on the occasion of the exhibition of
CUT & SEA at Oil Street Art Space (16th December 2017
– 22nd April 2018). It is the first of a trilogy of exhibitions
and adjacent publications planned for autumn 2019 at
the Goethe-Institut Hong Kong and in spring 2020 at the
University Museum and Art Gallery, The University of
Hong Kong.

Exhibition

Curated and organised by

Oi! 油街實現

Publication

Published by

University Museum and Art Gallery, The University of Hong Kong
香港大學美術博物館

Supported by

School of Creative Media, City University of Hong Kong
香港城市大學創意媒體學院

Goethe-Institut Hong Kong 歌德學院

EDITED BY:

Harald Kraemer 孔慧銳 , Florian Knothe 羅諾德

PUBLISHED BY:

University Museum and Art Gallery, The University of Hong Kong
香港大學美術博物館

DRAWINGS / ILLUSTRATIONS:

Sze Chun Hui 許思進 , Tobias Klein

PHOTOGRAPHY:

Kai Fung Ng 吳啟楓 , Sze Chun Hui 許思進 , Tobias Klein

TEXT:

Yasuhiro Kaneda 金田泰裕 , Tobias Klein, Florian Knothe 羅諾德 ,
Harald Kraemer 孔慧銳 , Ivy Lin 連美嬌 , Alfredo Wong 黃宇正

CHINESE TRANSLATION:

Simon Chung 鐘德勝 , Kikki Lam 林嘉琪

PROOFREADING:

Christopher Mattison 馬德松 , Fion Ng 吳彥真

DESIGN:

MAJO

PRINT:

Colham Printing Co Ltd 高行印刷有限公司

ISBN: 978-988-19025-4-2
October 2018 / 1st Edition / 1.000 copies